S0-BFB-691 5-

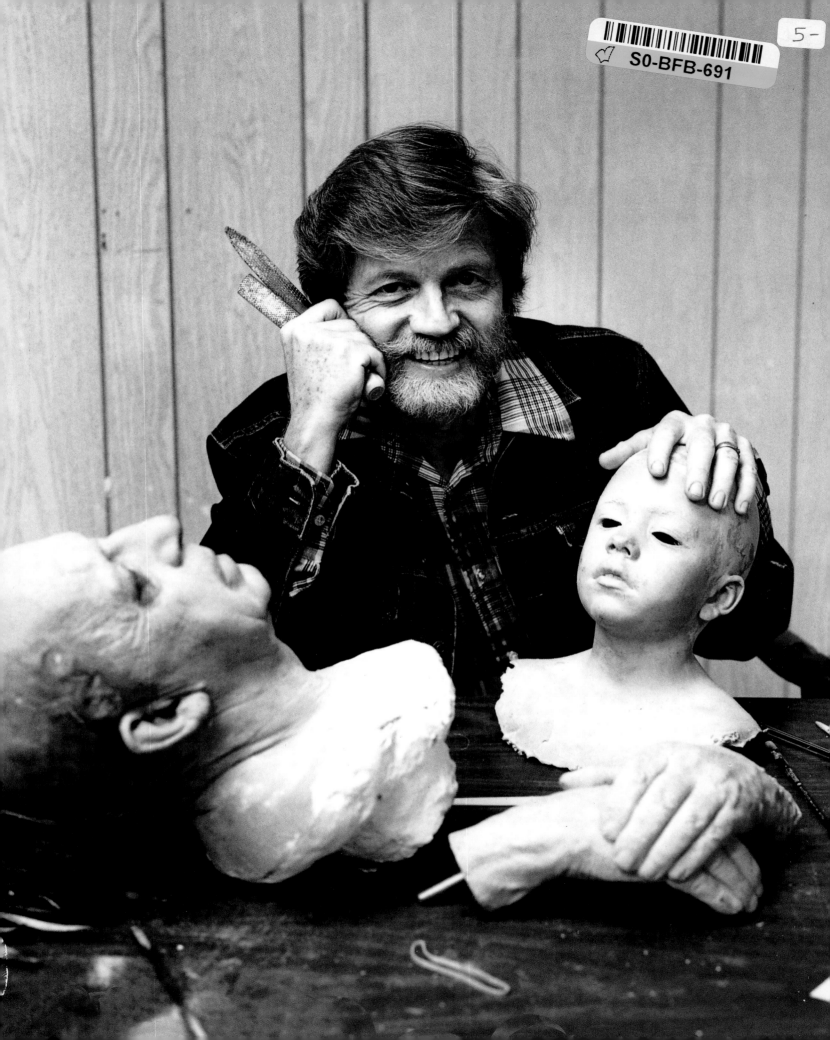

VIRTUAL

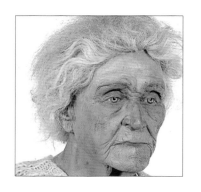

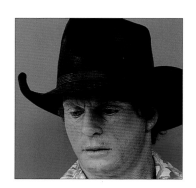

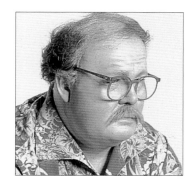

Christine Giles

Elizabeth Hayt

Katherine Plake Hough

Duane **Hanson**

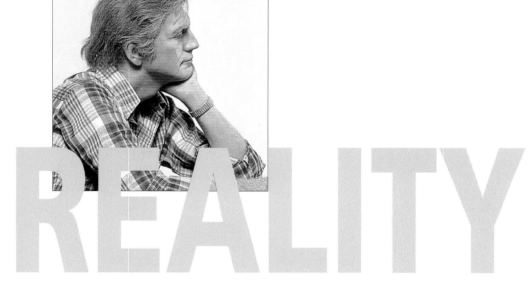

REALITY

PALM SPRINGS DESERT MUSEUM

Duane Hanson: Virtual Reality, was organized by Katherine Plake Hough, Director of Collections and Exhibitions, and was shown at the following institutions:

Palm Springs Desert Museum
Palm Springs, California
September 10–December 31, 2000

San Jose Museum of Art
San Jose, California
January 28–April 1, 2001

Nevada Museum of Art
Reno, Nevada
April 20–June 24, 2001

Portland Art Museum
Portland, Oregon
July 7–August 26, 2001

This project is funded by

The Henry Luce Foundation,
Palm Springs Desert Museum's Contemporary Art Council,
Palm Springs Desert Museum's Artists Council,
Brautigam-Kaplan Foundation,
Wilbert and Marybeth Waterman

Published by
Palm Springs Desert Museum
101 Museum Drive
Palm Springs, California 92262

Distributed by
University of Washington Press
P.O. Box 50096
Seattle, Washington 98145-5096

© 2000 Palm Springs Desert Museum
All Rights Reserved
Printed in Korea

Catalog design: Lilli Colton, Glendale, CA
Printing: Yon Art Printing, Korea/Overseas Printing Corporation, San Francisco

Cover: **Self-Portrait with Model (detail)** 1979; polyvinyl acetate and mixed media; polychromed in oil, with accessories; collection of Mrs. Duane Hanson

P. 1: **Duane Hanson** 1977
Photograph courtesy of Mrs. Duane Hanson

ISBN 0-295-98036-2

Library of Congress Cataloging-in-Publication Data
Hanson, Duane.
 Duane Hanson: virtual reality/Christine Giles, Elizabeth Hayt, Katherine Plake Hough.
 p. cm.
 Catalog on an exhibition held at the Palm Springs Desert Museum.
 Includes bibliographical references (p.).
 ISBN 0-295-98036-2 (pbk.)
 I. Hanson, Duane—Exhibitions. I. Giles, Christine, 1949– II. Hayt, Elizabeth. III. Hough, Katherine Plake. IV. Title.

 NB237.H254 A4 2000
 730'.92--dc21 00-044138

Table of Contents

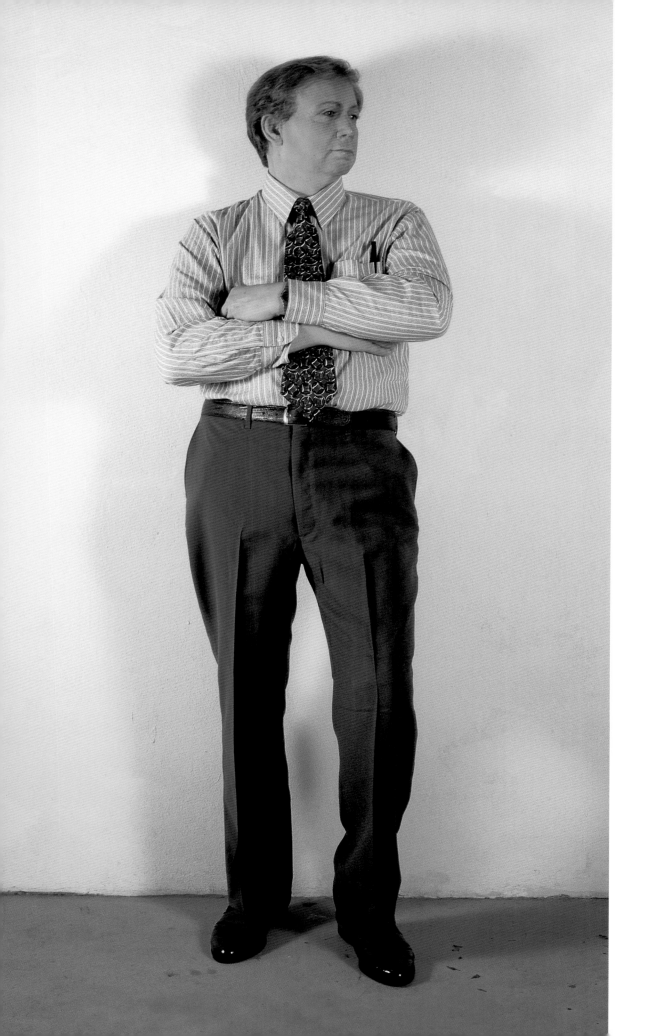

Car Dealer 1992–93
polychromed bronze and
mixed media, with
accessories
Collection of the Artist's
Estate

Man with Camera
1991
auto-body filler, fiberglass
and mixed media, with
accessories
Collection of Mrs. Duane
Hanson

Overleaf:
Flea Market Vendor
1990
auto-body filler, fiberglass
and mixed media, with
accessories
Private collection

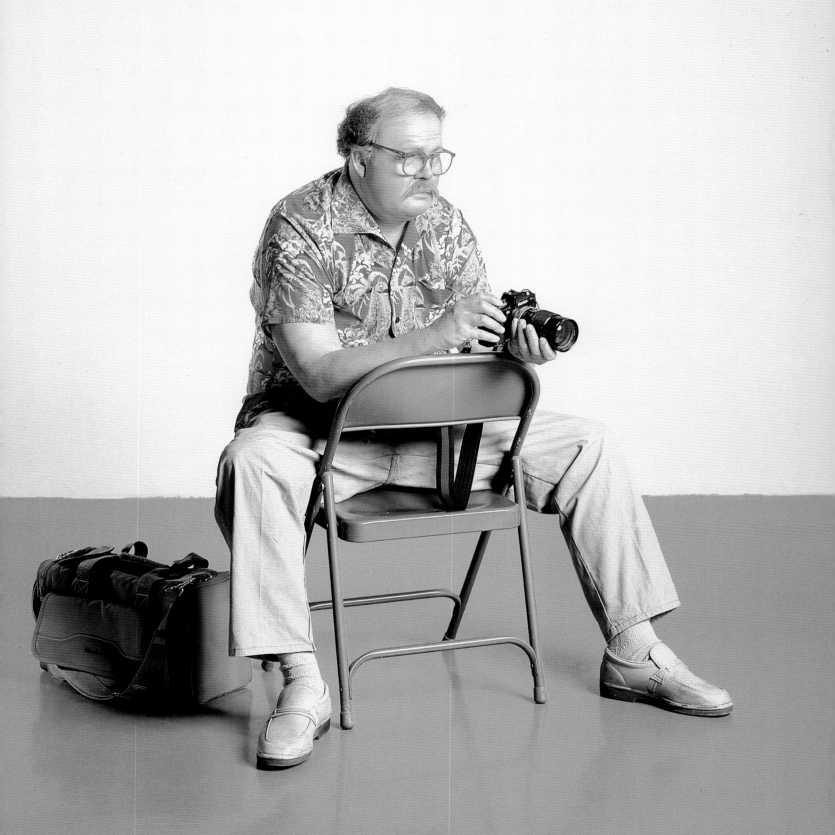

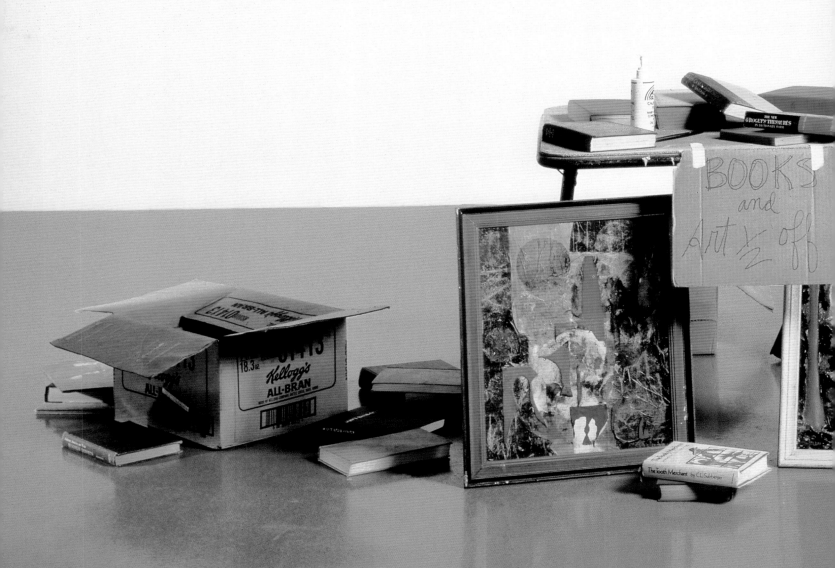

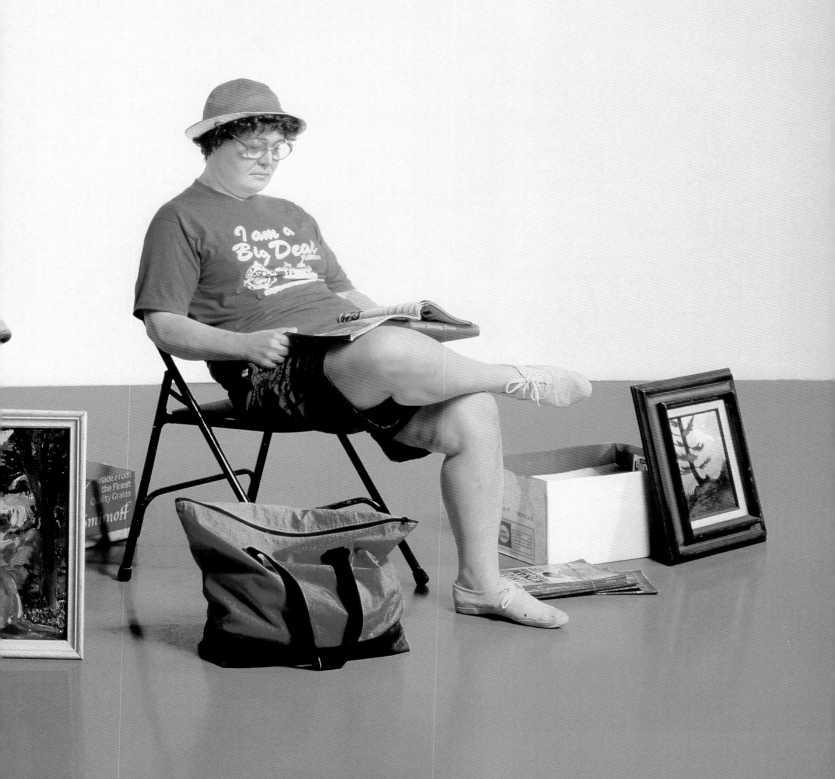

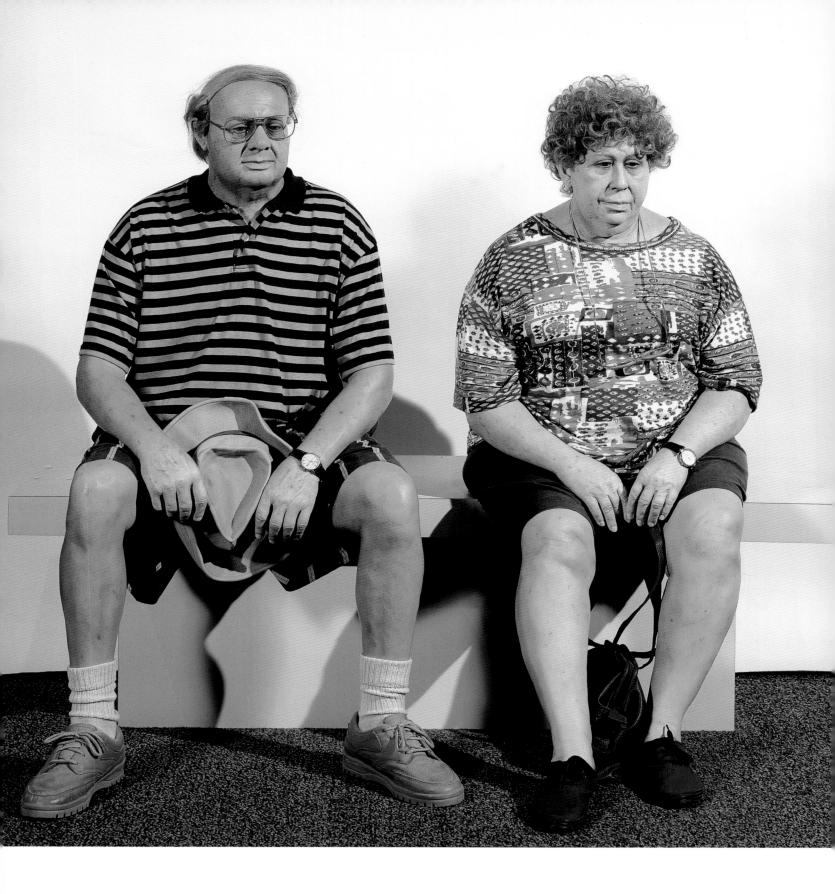

Foreword

Janice Lyle, Ph.D., Executive Director

Visitors to the Palm Springs Desert Museum have been able to examine Duane Hanson's sculptures for more than a decade. **Fancy Dude Cowboy (Slim)** has been on long-term loan from the Skerik Family Collection since 1989. **Old Couple on a Bench** was loaned by Mrs. Duane Hanson in 1996, and was subsequently purchased for the Museum through a generous gift from Bernard and Muriel Myerson. Thus, desert residents and tourists alike have become personally acquainted with two of Hanson's American types.

These pieces win the popularity contest as the favorite works of art in the Museum's collection with visitors. As with **Old Couple on a Bench**, it is possible on any day to see living examples of these older tourists sitting on chairs across the gallery from Hanson's version. Our Museum seems to provide the perfect venue for this work because of the unique social character of the desert and the real-life commentaries that can be made about our tourist community.

The opportunity to organize an exhibition of Duane Hanson's work and travel it throughout the western states was particularly exciting as it builds on our audience's already established interest. My thanks are extended to Katherine Plake Hough, Director of Collections/Exhibitions, for her persistence in making this exhibition a reality. Her curatorial expertise has ensured a provocative and beautifully presented exhibition with a catalog that assists in our understanding of Hanson's life and work. The Museum staff is looking forward with great enthusiasm to our audience's reactions to the range of Hanson's art.

I am grateful to the many individuals whose efforts have made this project possible, especially the contributors to the catalog; the staff of the Collections/Exhibitions Division; Mrs. Hanson and the generous lenders to the exhibition; and the other museums participating in the tour. My sincere thanks also go to those who provided the necessary funding for this project: The Henry Luce Foundation, the Museum's Contemporary Art Council, the Museum's Artists Council, the Brautigam-Kaplan Foundation, and Wilbert and Marybeth Waterman. Finally, I thank Robert Armstrong, Palm Springs Desert Museum's President of the Board of Trustees, who supported the exhibition, and to whom the Museum is especially grateful. ■

Old Couple on a Bench
1995
polychromed bronze and mixed media, with accessories
Collection of Palm Springs Desert Museum: Purchase with funds provided by Muriel and Bernard Myerson
Photograph by Avra-Waggaman

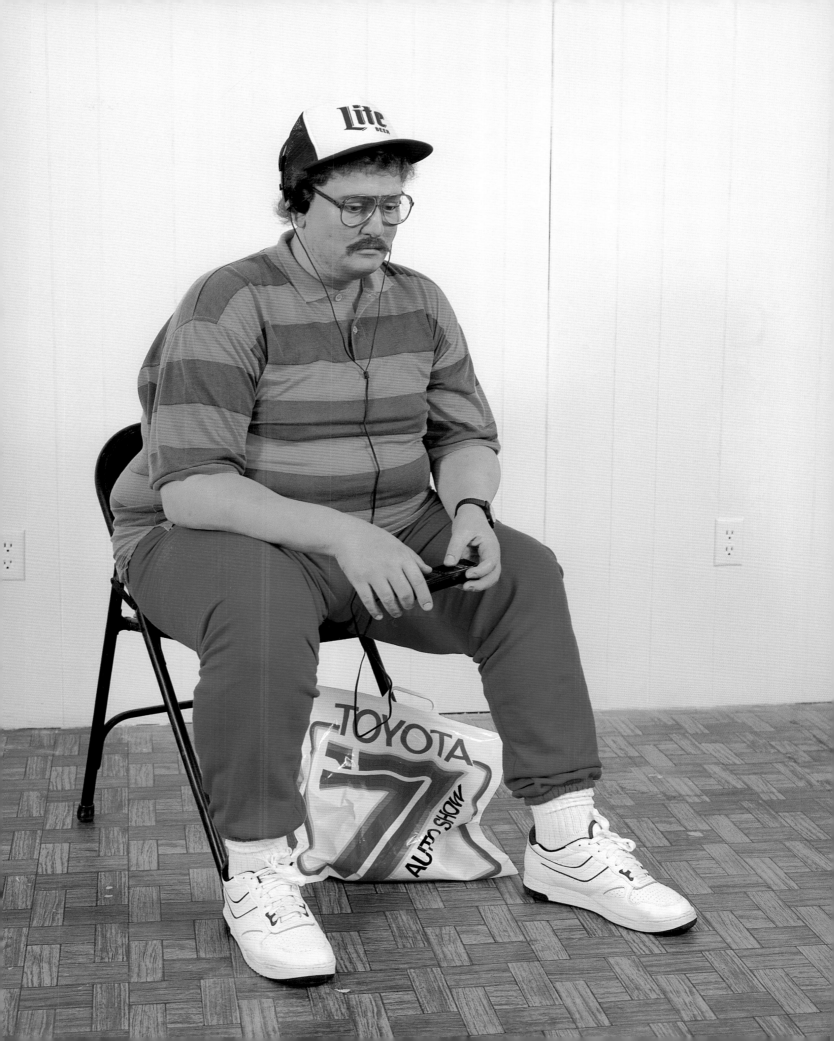

Introduction and Acknowledgments

Katherine Plake Hough
Director of Collections/Exhibitions

Greater emphasis on the human figure has returned to visual art in the last two decades. Walking through a gallery to scrutinize the realistic human figure in paintings and sculptures takes us on a journey of subtle emotions. As we examine the immobile configurations and attributes of the human figure, even in a cursory manner, we can't help but make comparisons to our own bodies and to our own experiences. Newer explorations of the body—through performances, videos, and computerized transformations—have expanded these opportunities to look at ourselves and, in so doing, examine the human condition.

Duane Hanson (1925–1996)—along with George Segal, Edward Kienholz, and John De Andrea—was a significant American artist who played an important role in influencing the current rage in hyper-realistic figuration as seen in works by artists such as Dinos and Jake Chapman, Charles Ray, and Vanessa Beecroft. Hanson's sculptures have helped lead the way to the development of the late 20th-century art movement first identified as Mannequin Art and associated with artists like Paul McCarthy and John Miller, among others.

For this catalog, we invited New York journalist Elizabeth Hayt to write about Hanson's work as it relates to that of contemporary artists who examine the human body as a vehicle for social commentary. Our information about Hanson's work has been enhanced and complemented by Hayt's insightful essay. In addition, a number of artists and galleries provided photographic materials and granted reproductive permissions for the works pictured and discussed in this publication. We are most appreciative of their assistance.

Duane Hanson: Virtual Reality brings together 24 figurative sculptures created between 1976 and 1995. Hanson's life-size figures portray American narratives and social types while balancing brutal honesty with compelling tenderness. They hold physical and psychological weight, prompting us to question our place in

Man with Walkman 1989
auto-body filler, fiberglass and
mixed media, with accessories
Collection of the Artist's Estate

contemporary American society. The sculptures of everyday Americans at work and play reveal attitudes about youth, prosperity, physicality, and aging.

An exhibition of this size cannot be accomplished without concerted teamwork. My deepest gratitude is extended to the artist's wife, Mrs. Duane (Wesla) Hanson, whose eagerness to provide support, valuable information, and advice over a four-year period has made this exhibition and its accompanying publication possible. Beyond her generosity in loaning major artworks from her private collection, that of her family's, and the Duane Hanson Estate, she has provided photography for this publication and has shared initimate knowledge of her late husband's artwork.

I was introduced to Duane Hanson through my acquaintance (and Hanson's cousin) Dale O. Skerik. In fact, the Skerik family's sculpture, **Fancy Dude Cowboy (Slim)** has been on loan to this museum since 1989. In a dialogue with Hanson over a period of months in 1992, we discussed the possibility of an exhibition in Palm Springs. He expressed interest in exhibiting here, but failing health and pressing projects postponed the project. After Hanson's death—and with Skerik's encouragement—Mrs. Hanson agreed to assist us with the organization of a West Coast traveling exhibition, which she knew her husband wanted and had approved. (The most recent solo exhibition shown in the West was a traveling exhibition organized in 1976 by the Edwin A. Ulrich Museum of Art, Wichita State University, Kansas.) Now, almost 25 years later, Hanson's work will be seen in the West due in large part to Mrs. Hanson's gracious encouragement, eagerness, and generosity.

I also offer special thanks to Billie Milam Weisman, Director of Frederick R. Weisman Foundation and Registrar, Mary-Ellen Powell, for the loan of sculptures from Frederick Weisman Entities. They have been generous in agreeing to loan works for the duration of the exhibition tour.

We are very proud to share the works with West Coast audiences. The spirit of support extended by the directors and curators of the host museums—Susan Landauer, Chief Curator and Patricia Hickson, Associate Curator, San Jose Museum of Art; Steven High, Executive Director and Diane Deming, Curator, Nevada Museum of Art; and Executive Director John Buchanan, Jr. and Donald Jenkins, Chief Curator, Portland Art Museum—has been evidenced by their willingness to participate in the endeavor.

The Palm Springs Desert Museum staff, whose cooperation and diligence are apparent in both the visible and invisible aspects of the exhibition and its accompanying

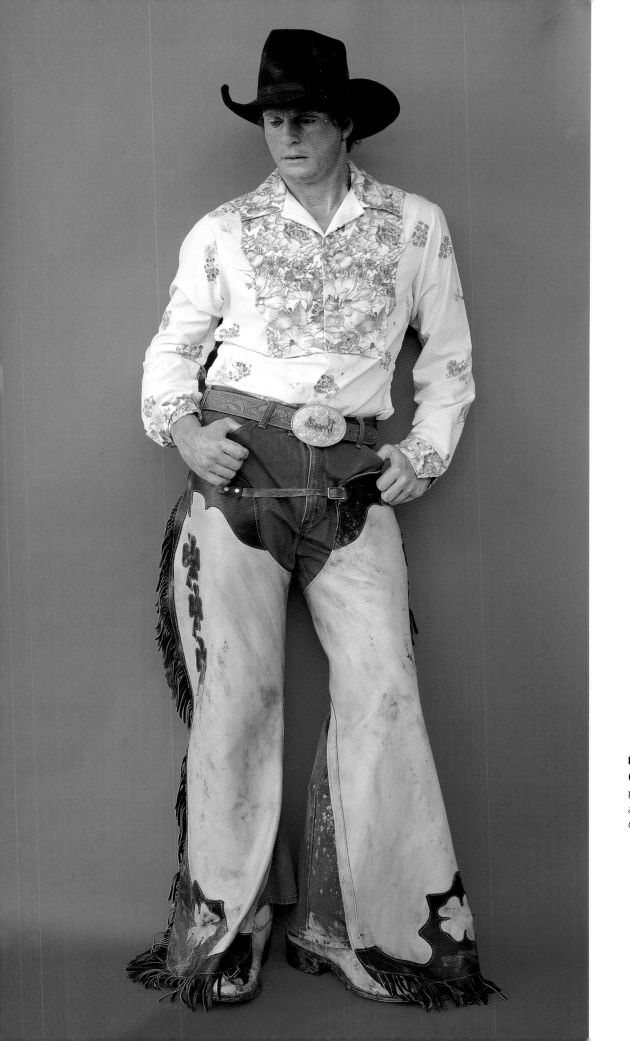

**Fancy Dude Cowboy
(Slim)** 1986
polychromed bronze with
accessories
Collection of the Skerik Family

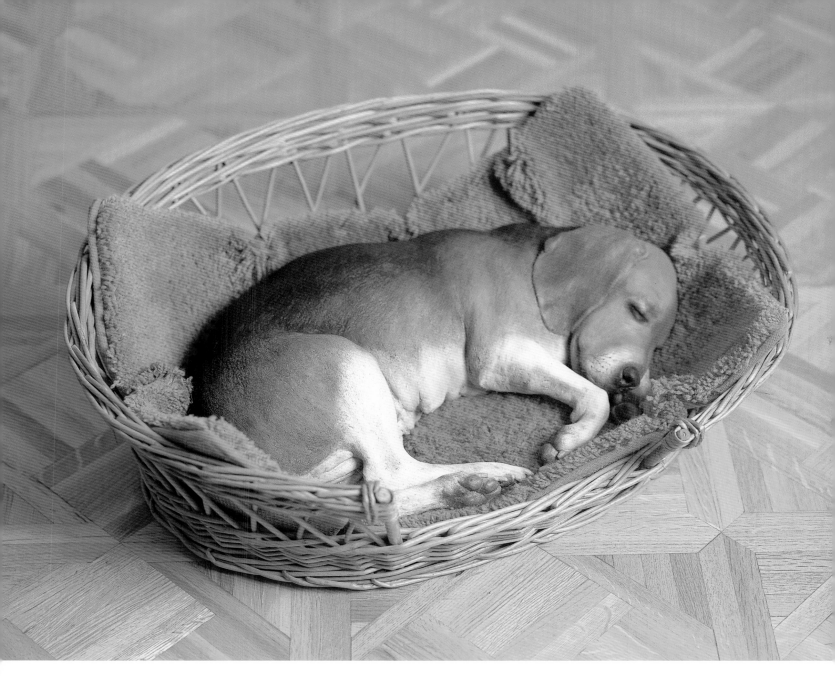

Beagle in Basket 1989
polychromed bronze and mixed
media, with accessories
Collection of Mrs. Duane Hanson

publication, worked attentively to make this undertaking possible. Assistant Curator of Art, Christine Giles, has written a biographical essay on Hanson and his place in recent art history; she also assisted with the exhibition development and catalog production. Curatorial Assistant, Terri Dettmers, conscientiously attended to myriad details associated with the exhibition/tour organization and catalog production. Donald Urquhart, Registrar, assisted with catalog editing while making arrangements for the nationwide crating and shipping to assure the safe arrival, handling, and installation of artworks at each institution. Art Department Assistant, Cheryl Urrutia, compiled the biographical and bibliographic data with precision and secured the loan of photographic material for this publication. William McCracken, John Frank, Thomas Johnson, and Michael Volpone installed the exhibition with their customary skill and creativity. Sidney Williams, Director of Education/Programs and Tammy Ashworth, Assistant Director of Art Education, contributed to the success of the project by organizing innovative educational programs. The Education Coordinator scheduled numerous guided tours and gallery talks for students and adults. Librarian, Kenneth Plate, researched and provided reference material; Public Relations Manager, Lydia Kremer, provided excellent visibility for the exhibition; and Donna Craig, Development Associate, secured funding for the project. As usual, Executive Director, Janice Lyle, expressed complete confidence in the museum staff's ability to succeed in carrying off a major effort such as this one.

I am eager to acknowledge other individuals who have assisted us in a variety of ways: graphic designer, Lilli Colton, deserves high praise for the handsome design of this publication; Barbara McAlpine edited selected portions of the manuscript with precision and sensitivity. Tin Ly, Hanson's assistant for ten years, supervised the art handling and installation at each institution.π

The professional commitment of everyone involved in this project is apparent in this presentation of *Duane Hanson: Virtual Reality.* ■

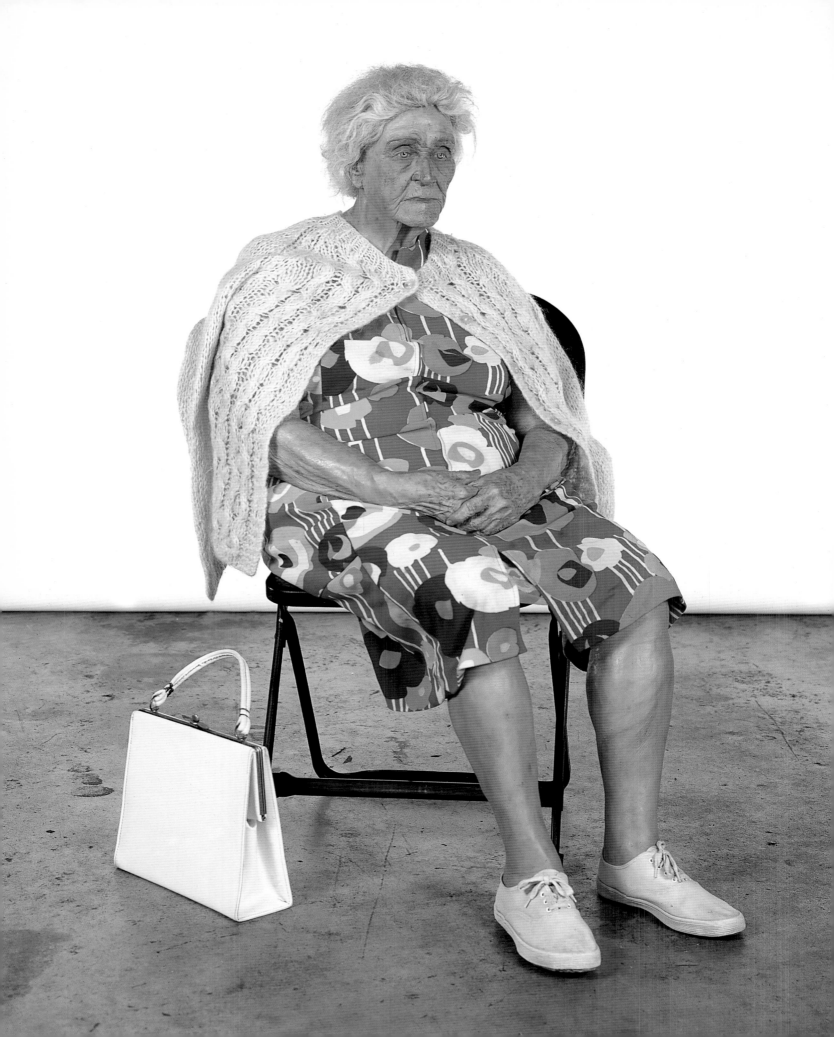

The Nature of Reality

Katherine Plake Hough

Duane Hanson didn't expect to find a singular truth that would reveal the nature of reality, but in his search he has expanded our awareness of it. By encouraging contemplation, he has opened our eyes to some of the mysteries and truths about the human experience. He pursued sculptural solutions that marked his distinctive place in the history of art. With a challenging eye, he portrayed the present with a view to the future, and in so doing was successful in realizing his goal to create "significant form."

Hanson admired and was fascinated by the elderly, especially those who evidenced the results of living a tough life and the consequences of loneliness. **Old Woman in Folding Chair** (1976) elicits a strong response to the obvious despair that almost shrouds an underlying tone of dignity and pride. In a natural, resting position appropriate for this saddened mature figure, the sculpture is an example of Hanson's gentle and humanistic works. Hanson confronts the public with sculptures that evoke an emotional response to the plight of the aged, who are often ignored and sometimes become nearly invisible.

When encountering **Old Couple on A Bench** (1995, p. 10) in a museum setting, one can hardly distinguish this life-sized American couple, probably retired, from the many others just like them who have visited on an admission-free weekday. Are they resting in a confused daze before they re-board their tour bus? Their inattentive facial expressions stimulate a number of reactions. Is the couple exhausted, are they absorbed in their own thoughts, or are they just bored? Or is the couple, who appear to be married, bored with each other and their existence? We may guess that they've known each other for a long time—they almost look alike. By positioning their slumped forms so that they are looking downward—at nothing—Hanson has invited the public to come closer and to stare. Eye contact doesn't seem likely; the viewer is free to inspect.

Old Woman in Folding Chair
1976
polyester resin and fiberglass;
polychromed in oil, with accessories
Collection of Mrs. Duane Hanson
Photograph by Roy C. Crogan

Through astonishing realism, Hanson has established a relationship between the viewer and artwork that involves suspension of disbelief followed by embarrassment. We are shocked by their presence as we examine real clothing and accessories, marveling at how carefully Hanson has painted the bronze figures in flesh tones with a full complement of blemishes, age spots, moles, bruises, and veins under now-fragile complexions.

This work, representing a lifelike man and woman who appear to lack self-awareness or a semblance of "good taste" in either manner or clothing, might be considered a portrait bordering on cruelty in its merciless accuracy of detail. In fact, Hanson has played on clichés and stereotypes of "typical tourists." The work encourages us to think about how much we might have in common with this couple, whom we might otherwise feel inclined to ridicule.

In speaking about his sculptures in 1977, Hanson said, "The subject matter that I like best deals with the familiar lower and middle class American types of today. To me, the resignation, emptiness, and loneliness of their existence captures the true reality of life for these people.... I want to achieve a certain tough realism which speaks of the fascinating idiosyncrasies of our times."[1]

The inspiration for **Self-Portrait with Model** (1979) came from a photograph taken of the artist seated across from his sculpture, **Woman Eating** (1971). Although reluctant to do a self-portrait, he was intrigued with the concept of developing a setting consistent with the narrative ambiance of his other sculptures. To make the viewer feel as if in the presence of the actual scene rather than simply a witness to a detached representation of it, Hanson conveyed the subject matter with believable vitality. Confusing the boundary between fiction and reality, these figures seem to invade the viewer's personal space.

One way to interpret this work relates to the original photograph in which the artist has merely pulled up a chair to seat himself across the table from one of his sculptures, as if studying the effectiveness of his artwork. Another interpretation is that the artist is searching for an appropriate model for a new piece, and so is examining a possible candidate. We are lured to perceive the dual identity with an equally intense vision.

Details of the tableau with two figures seated at a coffee shop table encourage the viewer to walk around the setting and contemplate a sense of the lives, personalities, and provocative elusiveness that has been created. Vital to the illusion

Self-Portrait with Model
1979
polyvinyl acetate and mixed media; polychromed in oil, with accessories
Collection of Mrs. Duane Hanson

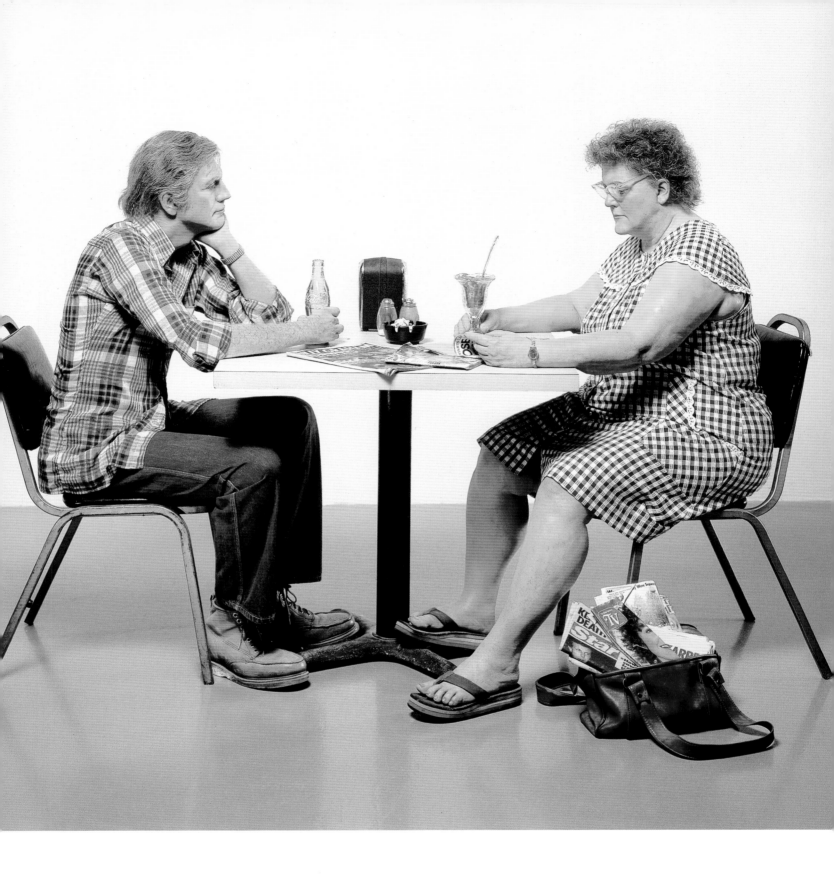

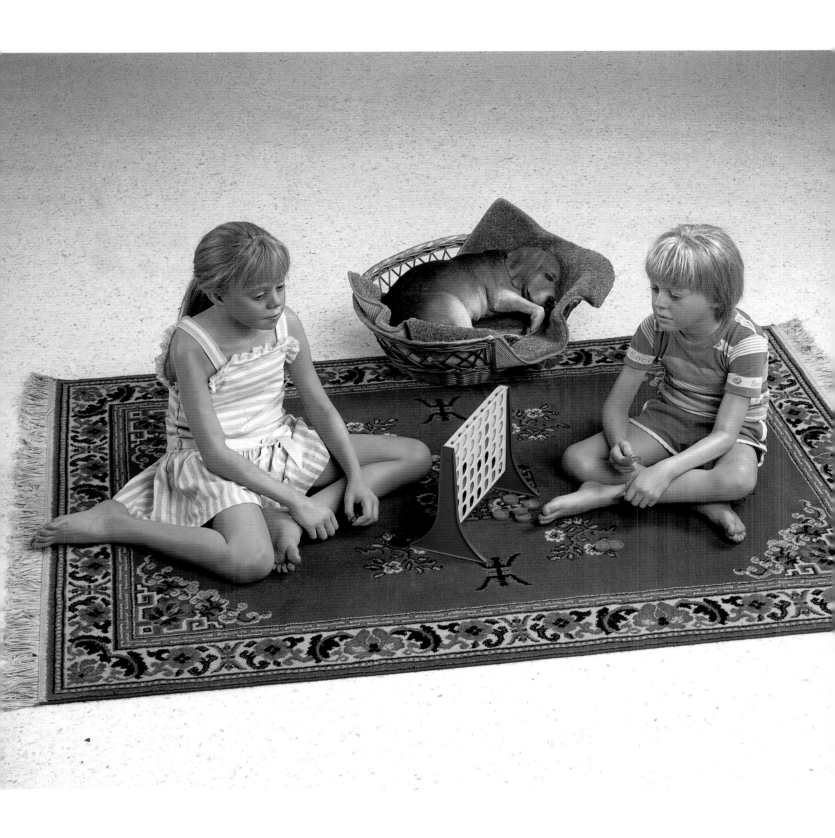

is the inclusion of eating utensils and other real objects incorporated with the cast figures. The total environment completes the narrative, rewarding viewers who linger for further examination. The lean artist studies an overweight middle-aged woman reading a *Woman's Day* article while polishing off a chocolate sundae. She communicates a sense of self-defeat and resignation even as she is drawn to yet another fad diet. The implication is that she not only lacks self-control but that she has no awareness of her self-defeating behavior.

Over the years Hanson asked relatives and friends to model for him. While the art-works are live casts from familiar individuals, they are neither anonymous nor are they portraits of real people. Hanson selected his models based on a particular type of person, body, or face to best fit the subjects he had in mind. He was especially partial to wrinkles, potbellies, and double chins. He positioned his models in a nat-ural and relaxed pose to capture an emotional gesture of unconscious self-immer-sion. Once a pose was selected, models were covered in plaster gauze to begin the mold-making process. Polyester resin and fiberglass or bronze were later poured into the mold. As in traditional sculpture making, Hanson pieced body parts together, sometimes constructing a figure with limbs from different models. A basic figure would then emerge for Hanson to rework and repair in preparation for the sur-face to receive paint, hair, clothing, and accessories. Props and clothing were care-fully chosen from thrift and junk shops or donated by sitters. The relationships between the figures and the objects provide vital clues to the intent behind Han-son's sculptures.

In a departure from figures that show middle-aged or elderly Americans struggling to survive in contemporary life, Hanson also created sculptures that celebrated the pleasures and innocence of childhood.

> Traces of nostalgia and fatherly pride inevitably enter into the tender por-traits he has made of his children over the years. The poignancy we expe-rience about the brevity of life and fleeting nature of time, when looking through our old photographs, is conveyed with extraordinary urgency in such works by Hanson. Such is the case with **Child with Puzzle**, the first sculpture he made of his daughter Maja, then aged six, one of his rare excursions into the depiction of small children. Featured again in **Children Playing Game** 1979, accompanied by her younger brother, Duane Jr....[2]

High School Student (1990, p. 26) was one of several similar sculptures that fea-tured Duane, Jr. The surfer shirt, shorts, sneakers, white socks, sunglasses, and relaxed posture present him as a cool and confident American teenager. Executed

Children Playing Game 1979
polyvinyl acetate and mixed media;
polychromed in oil, with accessories
Collection of Mrs. Duane Hanson

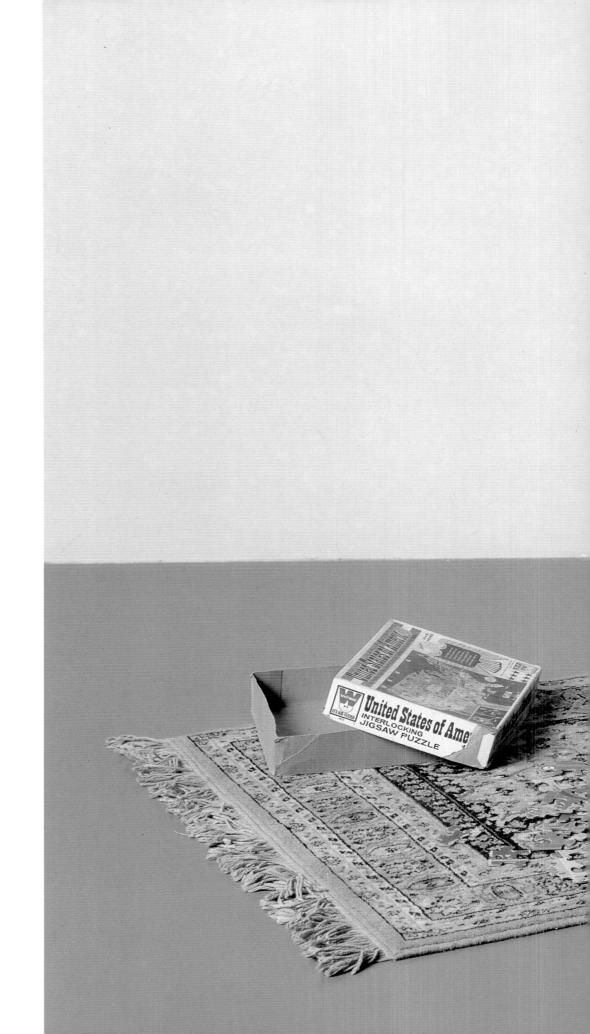

Child with Puzzle 1978
polyvinyl acetate and mixed
media; polychromed in oil, with
accessories
Collection of Mrs. Duane Hanson

in the same period, **Chinese Student** (1989–90, p. 40–41) is a direct contrast. This piece recalls the social conscience and passionate political stance taken by Hanson in a number of controversial works from his mid-career work of the 1960s. Although he didn't continue to pursue confrontational subject matter, his work of the 1970s and 1980s retained political undertones.

> Such is the case with **Chinese Student**, conceived in response to the suppression by the Communist Chinese authorities of student protests culminating in the bloody events on Beijing's Tienanmen Square in 1989. The issues raised about individual liberty, freedom of speech and other matters considered sacrosanct in western democracies were also being brought into focus by the sweeping changes taking place in the Soviet Union and in Eastern Europe. The failure of the Chinese authorities to allow their own society to be reshaped came as a bitter blow. It was not only because these events were televised as they happened that they felt so close to home, even though they were occurring on the opposite side of the world. As always, Hanson was able to put himself in the place of those who were directly affected. The young man who modeled for him here, Tin Ly, a Vietnamese painter of Chinese extraction, was himself an exile from such political turmoil; having by then become Hanson's main assistant, he was also one of his closest and most trusted friends.[3]

This sculpture has profound strength when the horror and compassion of the event register in the viewer's memory and its brutal implications are recalled.

The satirical **Flea Market Vendor** (1990, p. 8–9) is an example of many Hanson works that examine the tastelessness of the American middle class. Hanson surrounds a seated female figure with old books, outdated magazines, and questionable art purchased at a flea market for a fraction of the asking price. She is idly scanning a magazine while waiting for a customer. In describing this sculpture, Marco Livingstone noted that: "[Hanson] uses actual paintings by amateur artists, ranging from abstracts to vulgar and rather inept landscapes, to comment on the prevalence of bad art and on the precarious state of the art market after the boom years of the mid to late 1980s. Even at this low level of the business, poor sales have apparently forced the vendor to offer her wares at a 50% reduction."[4]

The T-shirt worn by the overweight woman is emblazoned with "I Am a Big Deal," triggering a series of sarcastic observations. And the junk she is selling is neither a "big deal" nor worth the discounted price. Her passive posture and the magazine she's reading communicates a sense of annoyance about collecting bad art. (Her magazine, a 1985 issue of *Sky*, is opened to an article about Hanson's work.)

High School Student 1990
polychromed bronze and mixed media, with accessories
Collection of the Artist's Estate

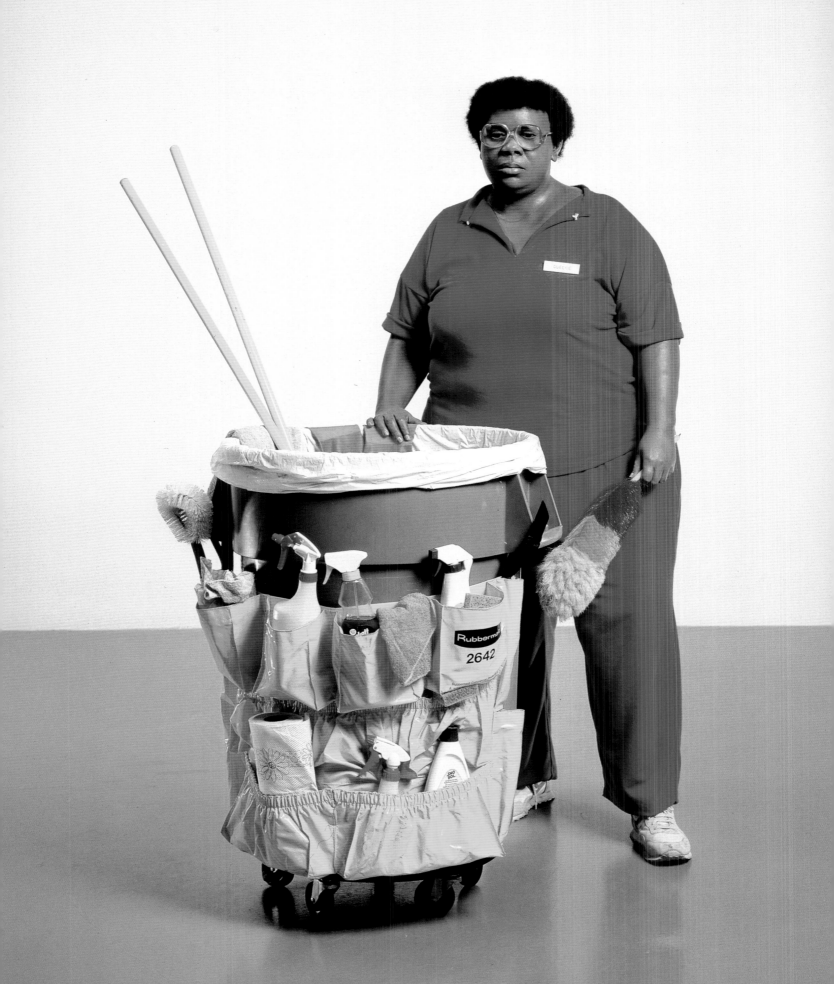

In another installation, **Lunch Break (Three Workers with Scaffold)** of 1989 (p. 78–79) occupies an expansive space. Scaffolding defines the place as a building site, and props are scattered around the figures. Each construction worker exists in his own private world. Clothing, tools, and hard-hats are personal extensions of the individual figures. Taking a well-deserved break from interacting with their fellow workers, these figures may be interpreted on several different levels. They are caught in a contemplative moment with an atmosphere of thought-provoking silence. Are they resting from their exhausting physical occupations? Why are they grim-faced? Are they sad or deep in thought? While Hanson has placed sculptures of people in real-life environments, his figures are never overwhelmed by their surroundings. The objects taken from "real" situations function as props that support the human content.

Hanson has created a number of sculptures that portray the blue-collar worker. Another one is **Queenie II** (1988), a serious commentary involving a cleaning lady. She pushes a rolling trash barrel slung with its own apron filled with cleaning materials. Her firm stance—one hand resting on the tools of her trade—reveals the pride that she feels in doing good work. She proudly holds her own against a mundane job and decidedly unglamorous life. Hanson has given **Queenie II** great dignity and poise. In **House Painter** (1988), a man's pose recalls the heroic stance of an ancient Roman soldier with spear in hand, even though this man is engaged in a routine activity.

The figure in **Car Dealer** (1992–93, p. 6) stands without props. He is dressed nondescriptly and gives few clues as to his profession. Standing nervously with arms crossed, he cannot relax. His shallow gaze and defensive approach divulge a lifetime of "sweet-talking" to make a quick deal.

Hanson's figures are most often shown in casual and contemplative moments. **Fancy Dude Cowboy (Slim)** of 1986 (p. 15), a ruggedly handsome cowboy with an athletically fit body and suntanned skin, is casually leaning against the wall in a relaxed posture. The model for this sculpture was a carpenter who had worked with horses. Hanson felt that the carpenter made a better cowboy than the real rodeo cowboy originally selected to pose.

The Body Builder (1995) has taken time to rest from his strenuous physical activity and is absorbed in thought. Doesn't he have something better to do? Wearing only shorts and shoes, **The Body Builder** reveals well-defined muscles, a demonstration of Hanson's ability to re-create the details of a body builder's impressive

Queenie II 1988
auto-body filler, fiberglass and
mixed media, with accessories
Collection of the Artist's Estate

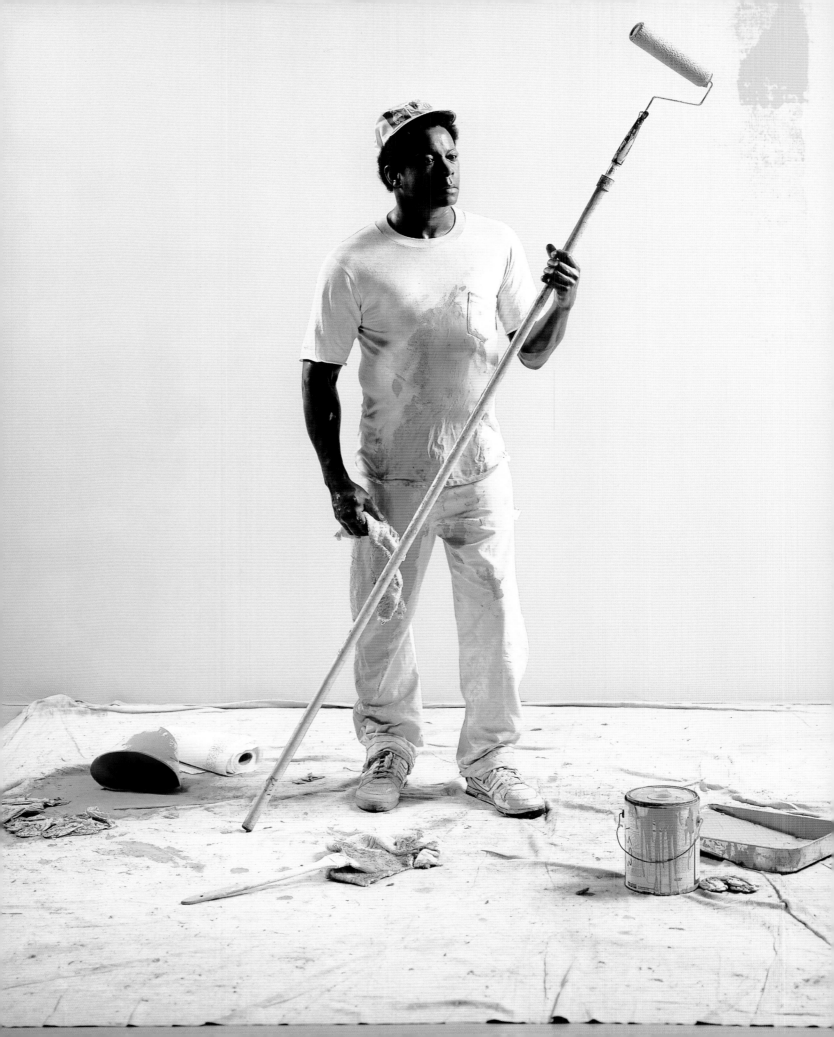

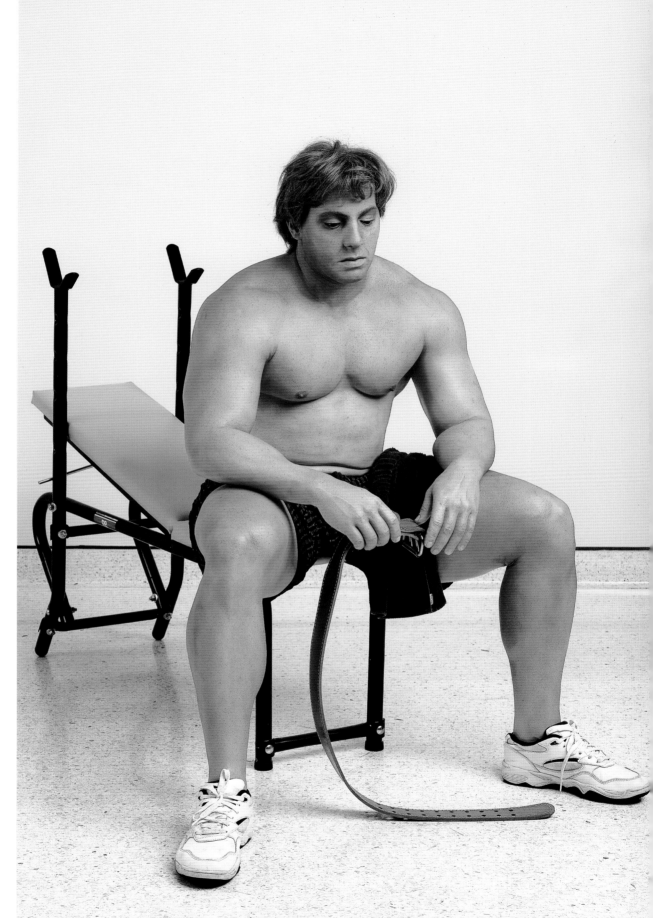

House Painter 1988
auto-body filler,
fiberglass and mixed
media, with accessories
Private collection

Body Builder 1995
auto-body filler,
fiberglass and mixed
media, with accessories
Collection of
Mrs. Duane Hanson

physique. Discussing an earlier version of **The Body Builder** in a 1995 Duane Hanson retrospective catalog, Marco Livingstone wrote:

> The near nudity allows the artist a rare opportunity to create a contemporary version of the perfection of ancient classical sculpture, not as an idealized vision of the body but as a naturalistic representation of a physique that is itself highly stylized in its exaggerated musculature. Through a regular regime of lifting weights, the body builder has in a real sense sculpted his own body into the desired shape and in so doing has turned himself into a living work of art. By memorializing him in bronze, Hanson has completed the task and given permanent form to transient flesh.[5]

In the majority of his pieces, Hanson captured the essence of American life. He had a great affection for ordinary working-class people and the elderly, not only describing their dignity and anxiety about contemporary life, but also their fatigue and frustration with the daily grind. He selected individuals who have endured the heavy burdens of life without realizing the American dream. Hanson was concerned with the social issues and quality of American life, and he portrayed boredom, despair, emptiness, and life's tragic side. He denied, however, that he was duplicating life. "I'm making a statement about human values. My work deals with people who lead lives of quiet desperation. I show the empty-headedness, the fatigue, the aging, and the frustration. These people can't keep up with the competition. They're left out, psychologically handicapped."[6]

Far from being repulsed by these desperate individuals, we are intrigued, and we respond with empathy to the conditions of their lives. They are portraits of personal feelings, attitudes, and states of mind and being. Hanson has spoken to the world about Americans.

In the last year of his life, Duane Hanson made his first entirely cast polychrome bronze in which even the hair and clothes were cast, enabling this sculpture to be installed out-of-doors. **Man on a Lawnmower** (1995) portrays a stereotypical figure of a man with a flabby stomach and an inactive pose that might first appear comical. But as we contemplate the piece, we realize that there is a serious side to this situation of the overweight American riding instead of walking. The choice of clothing and props such as the John Deere mower, a sweat-stained T-shirt, and a Coke demonstrates the artist's mastery of accessorizing his figures. Seemingly mundane objects, such as the brand of soda held by a figure, play important roles in creating the whole. To have a stronger and compelling impact on the viewer, Hanson discovered that if the figures were unemotional and naturally integrated with the accessories and props, he could blur the line between reality and illusion. The

Man on a Lawnmower
1995
polychromed bronze with
Coke and John Deere
lawnmower
Collection of the Artist's Estate

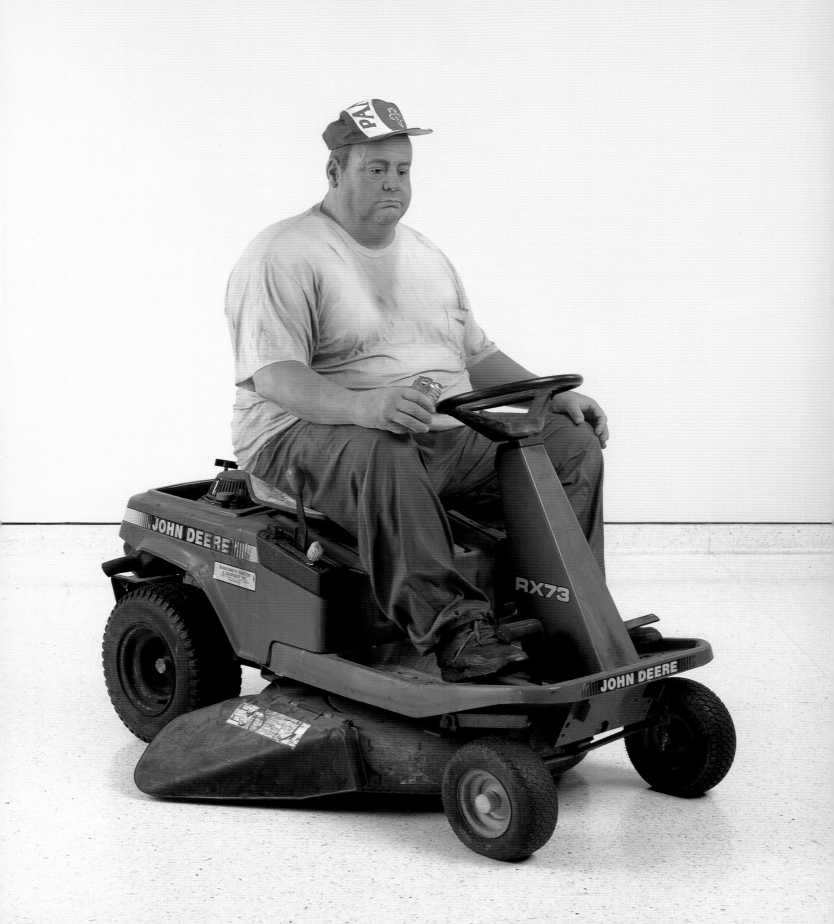

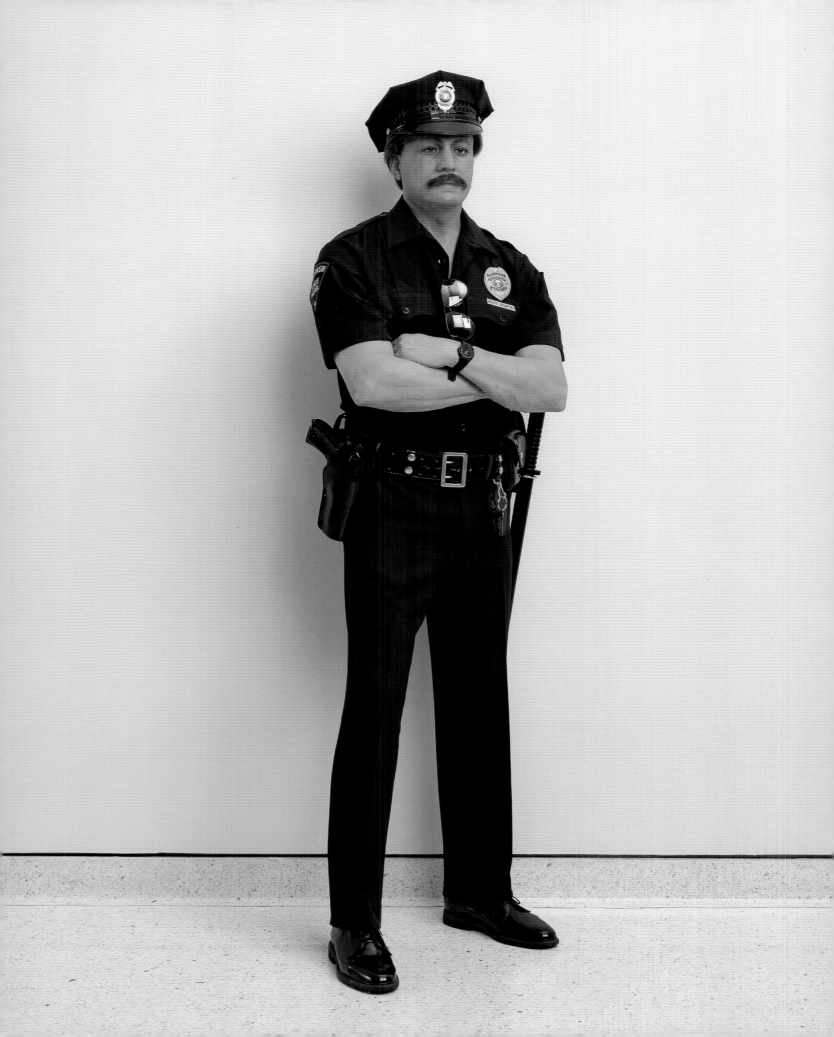

psychological and physical dialogue that occurs between the figure and the props makes a Hanson sculpture complete.

Man with Walkman (1989, p. 12) is another example of a satirical comment on an overweight, jogging-suited American sitting instead of walking. This man's dead-pan calmness invites responses from the viewer that range from sympathetic sentimentality to unkind disgust. As with **Old Couple on a Bench**, to make the figure more accessible for prolonged inspection and encourage a more thought-provoking relationship, Hanson intentionally posed the man gazing downward and wearing glasses; there can be no direct eye contact with the viewer.

Man with Camera (1991, p. 7) is seated in a metal folding chair and is about to bring his camera up to his eyes and take a picture. Rather than walking by without stopping, the expectant observer might stand by to witness what the photographer will capture with his camera. The Hawaiian shirt and camera indicate that he's a tourist set out to record his "adventures" on film. His seemingly emotionless observations imply that although he has traveled the world, he's seen little of it.

While Hanson is best known for his politically charged sculptures of the 1960s and his overweight figures, executed right up to his death in 1996, he also created a group of sculptures that portrayed more affluent members of American society, along with some in positions of trust and authority. His two sons from his first marriage (a doctor and a policeman) agreed to be cast for sculptures in which they portrayed themselves. In reference to **Medical Doctor** (1994, p. 61) and **Policeman** (1994), Hanson said that these figures represent "important signposts or symbols in the society."[7] Our relationship to the uniformed policeman is determined by our own attitudes toward the type of person portrayed. He can be perceived as a member of a caring profession dedicated to the protection of society, or as a threatening law-enforcement officer with weapons handy. His no-nonsense aggressive stance with arms folded is seen as both daunting and protective. Although he appears aloof, he exudes authority. **Security Guard** (1990, p. 54) is another thought-provoking example of an ordinary American whose identity becomes synonymous with his uniform, and whose blank expression belies his thoughts.

The location of Hanson's sculptures within a museum plays into their effectiveness as visitors come upon them. From across the gallery or from only a few feet away, the works elicit an emotional reaction. For example, the uniformed **Security Guard** blends into a museum environment and amazes the viewer who discovers that the standing figure is actually a sculpture. The eerie feeling of being watched by what turns out to be a work of art is a slightly disconcerting experience. Contemplation

Policeman 1994
polychromed bronze and mixed media, with accessories
Private collection

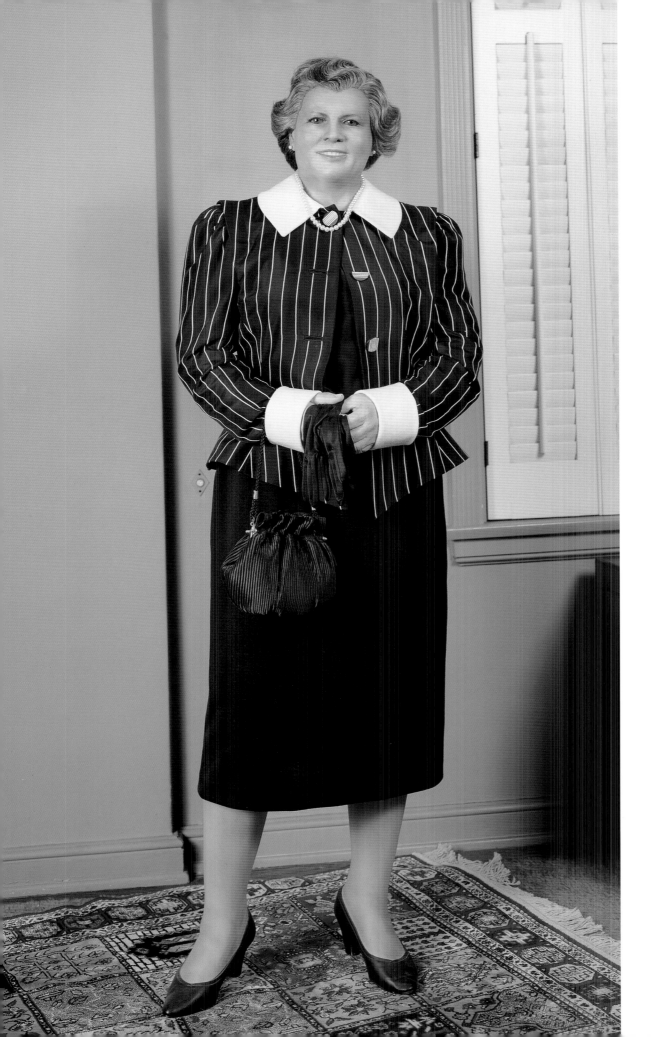

**Mary Weisman
(Mother of Frederick
R. Weisman)** 1994
polychromed bronze
with accessories
Collection of Frederick
Weisman Entities, Los
Angeles, California

**Executive on
Telephone** 1988
polychromed bronze
with accessories
Collection of Frederick
Weisman Entities, Los
Angeles, California

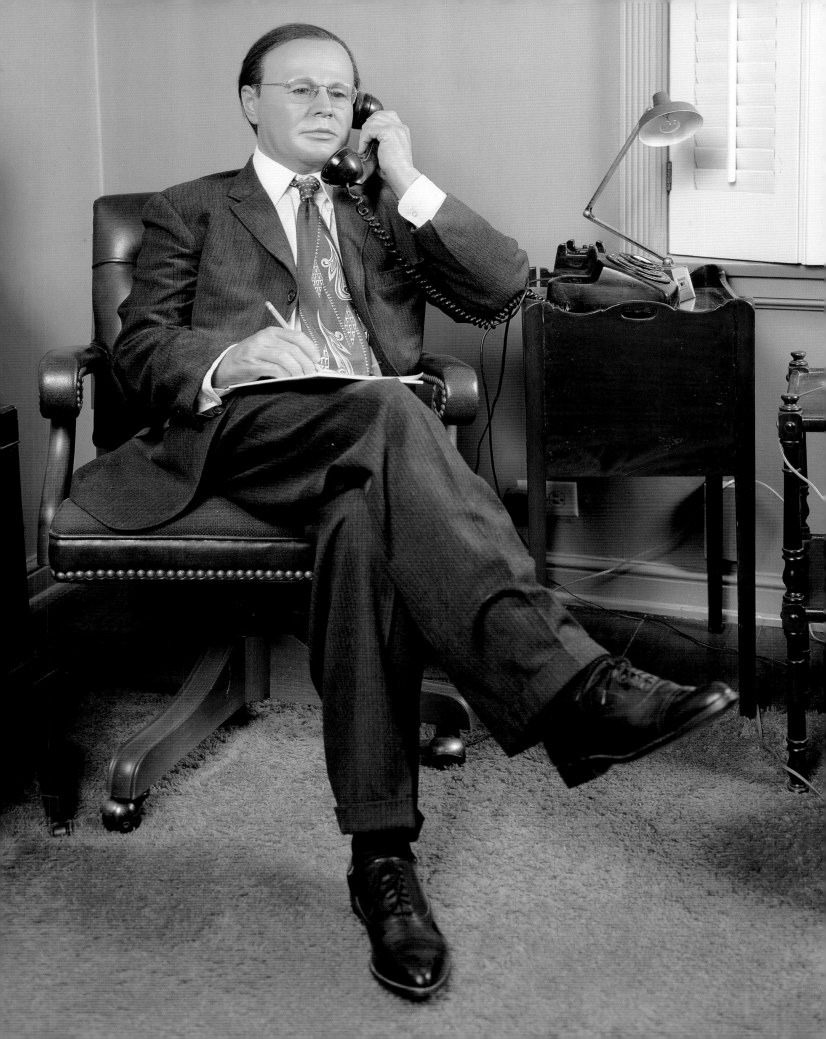

of what is real and what is not follows as one thinks about the objectification of the human image.

Other pieces that complete a panorama of contemporary American society and capture the human condition in different endeavors are **Mary Weisman (Mother of Frederick R. Weisman)** of 1994 and **Executive on Telephone** (1988). These works were commissioned by Frederick R. Weisman after the purchase of **Old Man Dozing** of 1976, a sculpture Hanson created using his own father as the model. Generally, Hanson avoided doing commissioned portraits of specific individuals; however, he accepted these particularly challenging commissions. Unable to create plaster molds from the subjects' bodies, he found models of similar stature and then hand-sculpted the facial features. Working from photographs of each individual, he created benevolent portrayals of Weisman's parents as affluent members of society.

Hanson's art is about addressing human attitudes—their fatigue, frustration, and rejection. By selecting ordinary individuals leading unremarkable lives—the cleaning lady, policeman, house painter, the elderly, and children playing—Hanson communicates the culture of America in the last quarter of the twentieth century and asks that we look at ourselves through them. He has given us an art accessible to many through different levels of observation and understanding. How we respond is central to the sculpture's success. The viewer undergoes a number of emotions when the deception is discovered—surprise, confusion, anger, or embarrassment at being fooled. The painstaking realism of this work enlivens our emotions and sense of human presence. Hanson's sculptures must be recognized as art in order to encourage reflection on the figures as ideas. His art encourages viewers to think more carefully about the human condition and to recognize intolerance and prejudices while contemplating our own existence. ∎

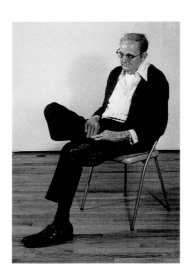

Old Man Dozing 1976
oil on cast vinyl with accessories
Collection of Frederick Weisman
Entities, Los Angeles, California
Photograph courtesy of the
Artist's Estate

Notes

1. Christine Lindey, *Superealist Painting and Sculpture* (New York: William A. Morrow and Co., Inc., 1980), p. 130.

2. Marco Livingstone, *Duane Hanson* (Tokyo: Art Life Ltd., 1995), p. 26.

3. Ibid, p. 67.

4. Ibid, p. 75.

5. Ibid, p. 78.

6. Duane Hanson, "A Fresh New Dimension to the Great Tradition of Realism," *Sculptures by Duane Hanson* (Wichita: Edwin A. Ulrich Museum of Art, Wichita State University, 1985), p. 15.

7. Livingstone, p. 87.

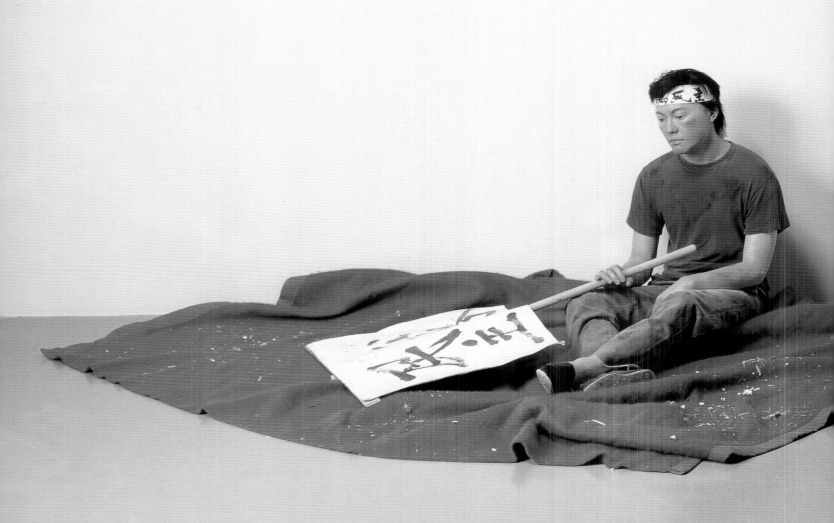

Chinese Student
1989–90
auto-body filler,
fiberglass and mixed
media, with
accessories
Private collection

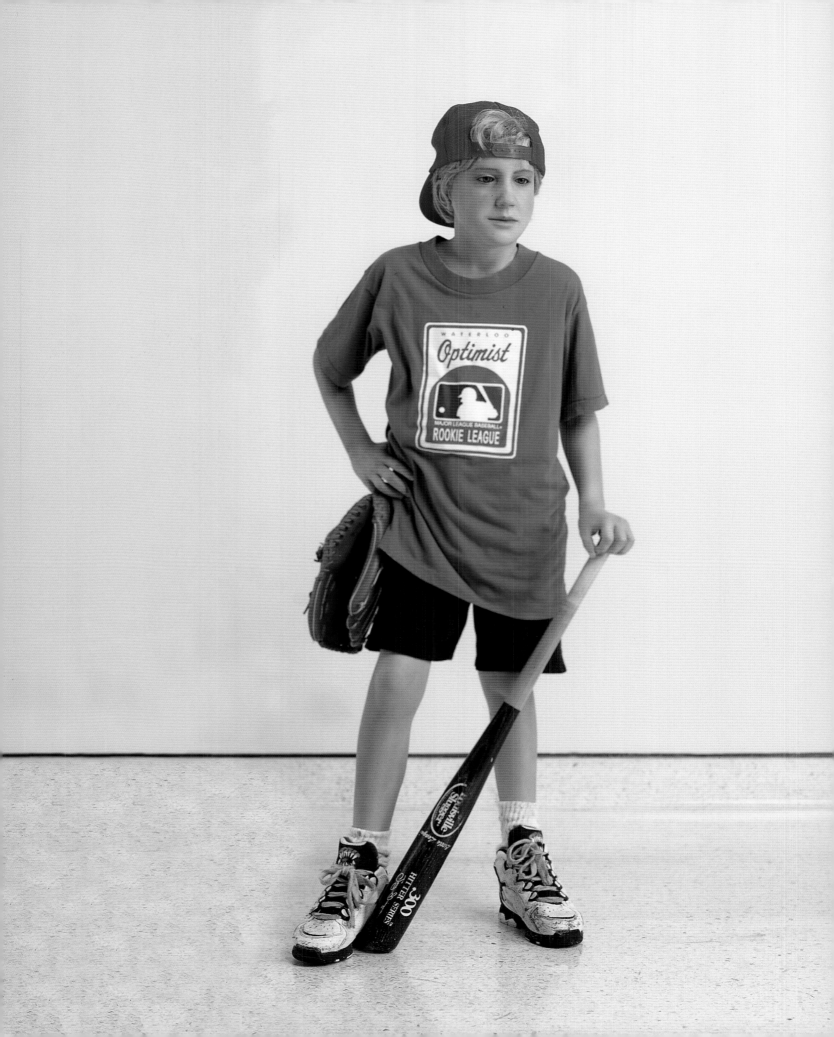

"Do You Know the Time?"
A Biography

Christine Giles

When I first saw Duane Hanson's **Fancy Dude Cowboy (Slim)** of 1986, my reaction was one of familiarity. I knew Hanson lived in Davie, Florida, a small farming and ranching town just north of Miami, and I had just been to the Davie Rodeo.[1] A year later, in a separate incident, I observed a man asking the **Old Couple on a Bench** of 1995 if they could tell him the time! These responses of recognition and familiarity are what attract us to Hanson's sculptures. His subjects are the common, everyday, down-to-earth Americans found in all cities and towns across the country. A personal response to Hanson's art was his intent all along: he wanted to make art that *all* people could enjoy and understand.

Initial reactions to his realist sculptures dating from 1965 to 1970, however, were not so friendly. In fact, the Miami art community's first response was one of outrage and the art critic for the *Miami Herald* declared that Hanson's sculptures were "not art." Also, Hanson's personal investment in "socializing" and "individualizing" his subjects contradicted the art climate that eschewed personal content in art for a more objective, "cool" approach promoted by Pop Art, Minimalism and the new Photo-Realists.

American realist painter Edward Hopper observed that: "in every artist's development the germ of the later work is always found in the earlier. The nucleus around which the artist's intellect builds his work is himself...and this changes little from birth to death."[2] An excellent illustration of Hopper's statement is represented by Hanson's **Blue Boy** of 1938, made when he was only thirteen. Worn by age and carved in a naïve manner consistent with his age, we are impressed by the young artist's talents and recognize the germination of his later artistic development. Working from an illustration of Thomas Gainsborough's popular painting, **Blue Boy**, Hanson translated the two-dimensional painting into a three-dimensional form—quite a feat for a thriteen-year-old. (Throughout his career, Hanson never was a "painter" in the strictest sense, although he applied paint his sculptures.)To

Above:
Blue Boy 1938
polychrome wood
Collection of Mrs. Duane Hanson
Photograph courtesy of the
Artist's Estate

Opposite:
Kid with a Baseball Bat
1995
auto-body filler, fiberglass and
mixed media, with accessories
Collection of the Artist's Estate

understand and appreciate Hanson's sculptures, then, it is important to review his life, early artistic developments, and contribution to the history of American art.

Hanson was born in 1925 in Alexandria, Minnesota. His parents, Dewey O. and Agnes Nelson Hanson were Swedish Americans living on a small, isolated dairy farm. A few years later, he moved with his family to Parkers Prairie, another small town (population about 700.) Hanson grew up in a closely knit family, proud of their solid middle-class values. He attended a one-room school with a library that had only one art book on its shelves, which he perused and found images painted by the English portrait painters Thomas Gainsborough and Sir Joshua Reynolds. In high school Hanson played the violin and piano, wrote poems and plays, and enjoyed acting. When Hanson turned eighteen in 1943, America was still deeply involved in World War II. He expected to join the military and fight for the cause, but allergies prevented him from serving. In 1944, after two semesters at a small Lutheran college in Iowa, Hanson moved to Seattle and attended the University of Washington. There he met Dudley Carter, the first influential artist in his life. Carter was a sculptor who carved with an axe. Hanson recalled, "That's what sculptors did in those days.... They carved with an axe or some crazy thing like that."[3] But Seattle was too far from home, and a year and a half later he returned to Minnesota and attended Macalester College in St. Paul. In June 1946 he became the school's first graduate to major in art.[4]

In 1950 Hanson enrolled in the Cranbrook Academy of Art in Bloomfield Hills, Michigan, a small town twenty miles from Detroit. Part art school, part museum, and part artist colony, Cranbrook was an exciting place for Hanson to make a serious study of sculpture, and in 1951 he graduated with a Master of Fine Arts degree. The Academy was founded on the principle that art should permeate every aspect of life. It offered graduate degrees in fine art and architecture with an emphasis on design. The resident architect who designed much of the complex was Eliel Saarinen, father of famed designer Eero Saarinen. Charles Eames and sculptor-designer Harry Bertoia also taught at Cranbrook. The Academy accepted only a limited number of students annually. There were no classes and no grades; instead, artists worked with a master artist and pursued their own projects. At Cranbrook, Hanson met Bill McVey, a stone carver, and Carl Milles, head of the sculpture department who had an international reputation for monumental sculptures. Hanson admired Milles: "Good words from Milles meant a lot to me. I loved his work. I still like it, but I think it really wasn't for me."[5]

Few of Hanson's sculptures from his school years through the 1950s have survived, except in photographs. What is important is that the subject of these early artworks

was always the human figure rendered in styles ranging from abstraction—the dominant style of the period—to realism. Referring to his early sculptures, Hanson remarked: "I would try to do abstract work, but I always put a bit of an arm or nose in it. I never could do just nonfigurative work."[6]

After graduating from Cranbrook, Hanson tried teaching at a Connecticut college. Discouraged that his work was suffering, he moved to West Germany where he remained for seven years. There he met sculptor Georg Grygo who had recently been commissioned to do a number of public sculptures in war-torn cities throughout postwar Germany. Hanson was impressed, not so much by Grygo's sculpture as by his technique of working with polyester resin and fiberglass. In 1960 Hanson returned to the United States to accept a teaching position at Oglethorpe College in Atlanta, where he experimented with Grygo's resin techniques. One of his first plastic pieces was a large relief of a bird designed for a building on campus. By his own admission, these early sculptures were more decorative than fine art. Even though he received a small grant for artistic investigation "in the experimental use of synthetic resins and other space-age materials,"[7] he continued to work primarily in traditional materials such as wood and plaster. Hanson, however, was at a stalemate in his career and unhappy with what he was doing, both technically and aesthetically: "I wasn't able to communicate my feelings or say anything about how I felt about our world. I wanted to do something that would be unique."[8]

Living in Georgia during the turbulent years of the civil rights movement shocked and disturbed the "Northerner." Segregation and racism were firmly entrenched in the South, and governors, legislators, and the resurgent Ku Klux Klan vehemently and often violently opposed change. Outraged, Hanson wanted to help expose bigotry and send a message directly to those who espoused hatred and violence. He began to make sculptures that would foreshadow the human concerns that would soon become the focus of his work. These early sculptures have not survived. One work was described as a "...piece conceived from some old teller cage bars-painted orange with a green figure behind them...."[9] Now 40, Hanson accepted a teaching position in 1965 at Miami Dade Community College in Florida, but the previous five years spent in Atlanta would prove crucial to the new direction his art would take.

In Miami, Hanson's concern for social and political issues persisted. After reading newspaper reports about the deaths of young women resulting from illegal abortions performed by unlicensed Cuban doctors, he again reacted with outrage. "I wanted to make a statement about why our society would force them to risk an illegal operation," he said. "Something had to be done to awaken the public."[10]

Hanson's "wake-up call" was a sculpture he titled **Abortion** (1965). It did more to stir conservative and reactionary dialogue about aesthetic issues, however, than it did to address his socio-political ideas. Only two feet in length (he later made a full-size version that was destroyed), **Abortion** depicts a figure of a pregnant woman lying on a table shrouded in a dingy white sheet. The soft folds of the fabric delineate her form in a manner similar to the treatment of drapery in Greek and Roman sculpture. This image, however, doesn't evoke a sense of beauty; rather, it is intentionally grotesque and provokes horror. The pregnant girl's right arm, bent at the elbow and laid over her chest, suggests the final pose of a corpse. Her gaping mouth is visible under the sheet that clings to her small body. Writing for the *Miami Herald*, Doris Reno's remarks were particularly scathing:

> This [**Abortion**] we do not consider a work of art, since we inevitably consider all such objects and such treatments as outside the categories of art. We find the subject objectionable, and continue to wish that such works which merely attempt to express experience in the raw could be referred to by some other term. This of course, is the newest thing in "sculpture," but that doesn't invalidate our contention that it is non-art.[11]

But "experience in the raw" was exactly the direction Hanson wanted his art to take, and major consequences resulted. Following the controversy surrounding **Abortion**, Hanson was informed by the administrators at Miami Dade Community College that he could no longer produce work in its sculpture studio.[12]

Although rejected by the local art community, **Abortion** marked a significant change in Hanson's work. Commenting in 1970, he said, "Here at last was something I deeply wanted to say about life around us today. But, more important, after years of uncomfortable ventures into abstract, nonobjective and conventional representative work...I had embraced realism as my mode of expression."[13] The ban didn't discourage Hanson from making sculptures with powerful social and political content, and he didn't abandon his interest in employing a grotesque style to make statements about the world around him. In fact, 1965 to 1970 would prove to be an important phase for Hanson—both in his choice of subjects and experiments with technique. Since childhood Hanson had known he was a sculptor. Now he knew he was a realist and was confident about his direction.

The themes following **Abortion** included violence, racism, murder, suicide, rape, war, and welfare. **Welfare-2598** of 1967 is a life-sized figure modeled in clay and covered with fiberglass. The gaunt corpse was placed in an old-fashioned black wooden coffin made by Hanson's father and uncle. "The sculpture dealt with a poor person dying and no one giving a damn about it," said Hanson. "There his

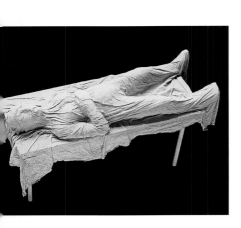

Abortion 1965
wood, cloth, plaster and mixed media
Collection of Mrs. Duane Hanson
Photograph courtesy of the Artist's Estate

body is, but it's just another number…. That's wrong…. Maybe it was a dumb idea. But the idea of death was very important to me at the time, and I wanted to share my feelings with others. Why shouldn't we protest the crazy, dumb things people do, particularly the bureaucrats."[14] Hanson viewed his art as his way of protesting—an attitude in keeping with the climate of the late 1960s.

In 1967 Hanson made his first body cast from a live model which he used for a sculpture of a partially nude girl who had been murdered in bed. This work was more frightening than earlier works and never was exhibited.[15] He made a second and third body cast, one of a young man hanging himself and the other of a young girl nailed to a tree after being raped. Along with these new and shocking subjects, Hanson was gaining control of his new materials and techniques, even if he wasn't sure where body casting would lead him.

Abortion and other sculptures of this period were influenced by contemporary social and political issues that had become a familiar part of the evening news. Yet Hanson had also been inspired by what many saw as the banal vulgarity of Pop Art. The work of George Segal he found especially interesting. "It was daring," he stated.[16] Segal worked from plaster molds cast from living models, which he completed with impressionistic and irregular surfaces. He often placed his figures in typical 1960s environments, complete with real objects such as beds, chairs, cola-dispensing machines, gasoline pumps, and traffic lights. Segal's technique and use of found objects influenced Hanson's sculpture. With a white sheet draped over the table and young body of a woman, **Abortion** bears a striking resemblance to Segal's white plaster figures of the same period, as seen in **Woman Standing in a Bathtub** of 1964.

Throughout 1967 Hanson continued to create life-sized works in polyester resin and fiberglass, such as **Motorcycle Accident**, **Gangland Victim** and **Trash**. For his sculpture **Gangland Victim** of 1967, Hanson was awarded the 1968 Florida

George Segal
American, 1924–2000
Woman Standing in a Bathtub 1964
muslin, plaster, wire mesh, bathtub, tile, wood and razor
Private Collection
Photograph courtesy Fred Hoffman Fine Art
© George Segal/Licensed by VAGA, New York, NY

Gangland Victim 1967
polyester resin and fiberglass; polychromed in oil, with accessories
Collection of The Art Museum at Florida International University; Gift of Mr. Jay Kislak and Mr. Nicholas Morley
Photograph by Eric Pollitzer, courtesy of the Artist's Estate

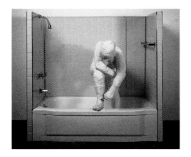
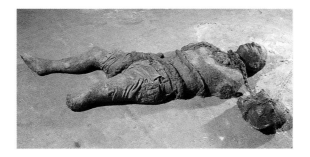

State Fair Award of Merit from no less than exhibition judge George Segal himself. The figure is dark and appears encrusted with mud, as if it had just been dragged from the bottom of Biscayne Bay. Both arms and one leg have been hacked off, and a chain with a weight attached to the end is tied around the victim's neck.

The year 1968 was an important one for Hanson. He had received recognition from a fellow artist he admired and soon attracted the attention of another important figure in the art world. Ivan Karp of New York's O.K. Harris Gallery had seen slides of Hanson's work. Along with Leo Castelli, Karp was instrumental in "discovering" the stars of Pop Art—Andy Warhol, Roy Lichtenstein, and Robert Rauschenberg. And Karp later launched the careers of a new generation of realists who became known as Photo-Realists. In reference to Hanson's work, Karp wrote, "The new works look splendid…do more work, send slides. Other interesting possibilities underway here."[17] After visiting Hanson's Florida studio in 1968, Karp promised him a New York exhibition if he would relocate.[18] Excited by the possibilities, Hanson moved to New York the following year. In the meantime, Karp had been showing Hanson's slides to anyone who would look at them and soon after his arrival in New York, Hanson was invited to include three works in the Whitney Museum of American Art's exhibition "Human Concern/Personal Torment: The Grotesque in American Art." Hanson's career was taking off.

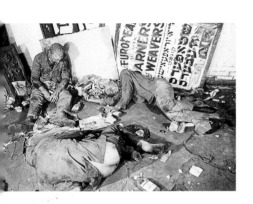

Bowery Derelicts 1969
polyester resin with accessories
Collection of Aachen, Ludwig
Forum für Internationale Kunst
Photograph courtesy of the
Artist's Estate

Bowery Derelicts of 1969 was inspired by what Hanson saw on the streets of New York City. It would be Hanson's final *expressionistic-realist* work and is a more restrained form of social realism compared with **Abortion** and **Gangland Victim**. His Bleecker Street studio was across from a Catholic church where the homeless were provided with daily meals. "I would look out the window and see them…. They would get soaked with alcohol during the day and lie around the sidewalks in front of our doorway. It was shocking. It's shocking to be confronted by these people living in the streets, vomiting, defecating, sitting in piles of garbage, covering themselves with pieces of cardboard on a cold night. I had to do something."[19] In **Bowery Derelicts**, three skid-row winos in an alcoholic stupor are sprawled out in the sidewalk surrounded by garbage, empty wine bottles, scraps of paper, and old clothes.

The political and social protest themes of Hanson's sculptures would soon be replaced by more common subjects. "Why not look right here at myself, shopping, driving?" Hanson thought, "…Why not look at this guy sitting right next to me, what's going on, what I see on the TV and in the newspaper. I think *that* was the breakthrough."[20] A major influence in Hanson's "breakthrough" was the advent of Pop Art in the early 1960s. Through Pop, Hanson was encouraged to select his subjects from

everyday life. It further confirmed for him that art did not have to be "on a pedestal, beautiful, far removed from everyday living."[21] Beginning in 1970, Hanson's subjects would be drawn from middle-class Americans engaged in banal and uneventful acts like shopping, sunbathing, working, reading, and just sitting.

Supermarket Shopper of 1970 and **Sun Bather** of 1971 mark the emergence of what Hanson referred to as his "Satirical Period." He described **Supermarket Shopper** as a symbol of the over-consuming housewife pushing a cart filled with every imaginable item that she could buy.[22] During a visit to South Florida in 1970, Hanson was inspired by the people he saw crowded along the beaches. **Sun Bather** represented the apathy of a growing public unconcerned about their physical appearance. Reclining with eyes closed, she is in "her own world", deep in thought. Her overweight body and casual manner was a "type" that would become a favorite of Hanson's. In contrast to these two sculptures, **Bunny** of 1970 represents the *Playboy* icon of America's obsession with sex. Life-sized, the voluptuous woman (modeled by Hanson's wife, Wesla) wears a skin-tight pink bunny costume. Comparing this work to a similar work by California Pop artist Mel Ramos, **Chiquita** of 1964 illustrates the influence of Pop Art in Hanson's art. Eroticism, however, would not become a recurring theme in Hanson's work.

Along with the change in subjects and themes, Hanson became more interested in the technical aspects of making his sculptures *more* realistic. To succeed in creating an illusion of reality, Hanson eliminated the idea of motion or action. Implied movement was banished from his imagery and replaced by the contemplative mood of his mature artworks. California Pop artist Wayne Thiebaud also removed elements of action in his figure paintings.[23] In **Man Reading** of 1963, a well-dressed man is seated in a chair reading a book. We are confronted with the top of his bald

Sun Bather 1971
polyester resin and fiberglass; polychromed in oil, with accessories
Collection of Wadsworth Atheneum, National Endowment for the Arts Purchase Program, with matching funds bequeathed by Roscoe Nelson Gray in memory of Rene Gabrielle Gray and Roscoe Nelson Dalton Gray
Photograph by Eric Pollitzer, courtesy of the Artist's Estate

Bunny 1970
polyester resin and fiberglass; polychromed in oil, with accessories
Collection of Monroe Meyerson
Photograph by D. James Dee, courtesy of the Artist's Estate

Mel Ramos
American, born 1935
Chiquita 1964
oil on canvas
Private Collection
Photograph courtesy of the Artist

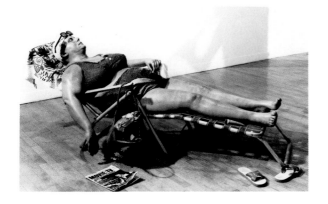
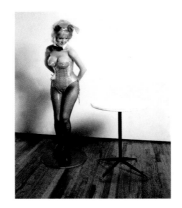
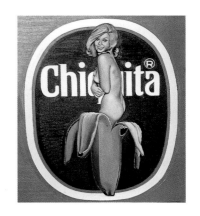

head as he leans forward to read. Like Hanson's figures, he is psychologically and physically isolated from others and from the viewer, and we approach these works as voyeuristic observers. As in Thiebaud's work, Hanson has removed the narrative content evident in his earlier "expressionist" sculptures and tableaux. The elimination of motion and narrative from his sculptures was to become charateristic of his mature works.

Ivan Karp liked the new work and gave Hanson his first solo exhibition in New York at the O.K. Harris Gallery, as promised. Hanson's works had become decidedly less confrontational and more illusionistic, a change that associated him with the new group of Photo-Realists painters including Richard Estes, Malcolm Morley, Chuck Close, Robert Bechtle, and others. Often working with thinly applied layers of paint, these artists created a "photographic" version of reality. The sculptures of Duane Hanson and John De Andrea, who worked from live body casts, were considered the three-dimensional version of Photo-Realism.

Influenced by Pop Art, Photo-Realists also selected banal and common place subjects and scenes such as the family stationwagon parked in driveway of a suburban tract house, or the objects in and reflected by an urban storefront display window. It's not hard to see why Hanson's work was initially grouped with that of Photo-Realists painters; they shared a similar interest in precision and in their subject matter derived from common, everyday images of America. But Pop artists and Photo-Realists insisted on a neutral stance, arguing in favor of formalist principles of art and an objective approach to their subjects. Hanson's concern for social and political issues distinguishes his style of realism from that of Pop and Photo-Realists. His early "tableaux" were in large part motivated by the social and political climate of the 1960s, and his 1970s figures were to retain a direct connection to social and humanistic ideas.

Hanson's technical precision and capacity to fool the eye are aptly described by one visitor's remarks: "As I jostled him I said, 'Excuse me.' But he didn't budge, didn't reply, and I realized he was a Hanson."[24] Despite a number of occurrences, it was never Hanson's intention, however, to *trick* the viewer. Although creating the *illusion* of reality was paramount in his work, according to Hanson:

> I wanted to comment and was criticized that I was doing it for shock. For me, I feel that I have to identify with those lost causes, revolutions and so forth. I am not satisfied with the world. Not that I think you can change it, but I just want to express my feelings of dissatisfaction…. If the artist doesn't reflect that…I don't think he is being honest. I try to be honest about what

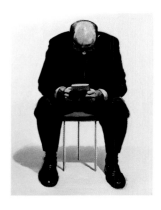

Wayne Thiebaud
American, born 1920
Man Reading 1963
oil on canvas
Private Collection
Photograph courtesy of the
Artist

I feel myself, and what others feel, and express it. If art can't reflect life and tell us more about life, I don't think its an art that will be very lasting and durable.[25]

In 1973 Hanson moved from New York back to the Miami area and settled in Davie. He often used family and friends as models. His wife, children, father, aunt, and even the family dog became sources for his works. Although Hanson selected family and friends to model, he insisted his sculptures were not portraits. Instead he tried to remain objective, preferring to call his subjects "types."

With Hanson's artistic success came a new attitude that would be reflected in his work: "It's a wild and wonderful world, and the most interesting part is the people. They have their problems, their beauty, and their black side, too. It's a tremendous challenge to pick up on that world out there and to confront people with themselves."[26]

Hanson's exhibitions expanded to the international arena in 1972 when his sculptures were featured in *Documenta 5* in Kassel, Germany, and were well received by critics. He went on to have several solo exhibitions in Germany and other European countries as well as in Australia and Japan. His solo exhibitions at O.K. Harris Gallery continued to be popular, and soon his sculptures were recognized and sought after by museums throughout the world. His works are collected by major private and public collections including The Nelson-Atkins Museum of Art, Palm Springs Desert Museum, Wadsworth Atheneum, Whitney Museum of American Art, Yale University Art Gallery, and numerous others.

In 1971 Hanson was diagnosed with cancer brought on by his early work with resins. The cancer returned in 1974 and again in 1995. He died in January 1996 at the age of 70. His legacy has immortalized twentieth-century America and the family and friends that touched his life. For Hanson art had to be about life, and realism best represented truth. With this aesthetic, Hanson's sculptures continue the tradition of American Realism, erasing the boundaries of art and time. ■

Notes

1. Just a 30-minute drive north of Miami, Davie is a throwback to the heyday of cattle ranches, farming, and cowboys. It is a piece of "small-town" America that you would expect to see in the Midwest or California's Sacramento Valley, not next to an international community like Miami which was fast-becoming the world's latest fashion hot-spot.

 Hanson decided not to use one of the local cowboys for this sculpture. It is instead based on a "type" that does, however, portray the local character of Davie, Florida.

2. James Hillman, *The Soul's Code: In Search of Character and Calling* (New York: Random House, 1996), p. xii.

3. Martin H. Bush, *Sculptures By Duane Hanson* (Wichita: Edwin A. Ulrich Museum of Art, Wichita State University, 1985), p. 26.

4. Ibid. p. 26.

5. Ibid. p. 27.

6. Marco Livingston and Laurence Pamer, *Duane Hanson: A Survey of His Work from the '30s to the '90s* (Ft. Lauderdale: Museum of Art, 1998), p. 8.

7. Ibid. p. 9.

8. Bush. p. 30.

9. Ibid. p. 30.

10. Bush, p. 31.

11. Doris Reno, "Taste Marks Sculptors of Florida Annual," (*Miami Herald*, October 30, 1966), p. 10-B.

12. Pamer (Fort Lauderdale) p. 11.

13. Ibid. p. 10.

14. Bush, p. 34.

15. Ibid. p. 34.

16. Ibid. p. 34.

17. This work was first titled *Crime Victim*—perhaps a reference to the Mafia and rising crime rate in Miami.

18. Ibid. p. 40.

19. Ibid. p. 41.

20. Marco Livingstone, *Duane Hanson* (Montreal Museum of Fine Arts, 1994) p. 17.

21. Ibid. p. 17.

22. Martin H. Bush, *Duane Hanson* (Wichita: Edwin A. Ulrich Museum of Art, Wichita State University, 1976), p. 26.

23. Thiebaud's early paintings associated him with Pop Art in the early 1960s. His classification with this group, however, has since been revised.

24. Roy Bongartz, "It's the Real Thing," (*Horizon*, September 1977) p. 74.

25. Ellen H. Johnson, *American Artists on Art from 1940 to 1980* (New York: Harper & Row, 1982), p. 167

26. Bongartz, p. 80.

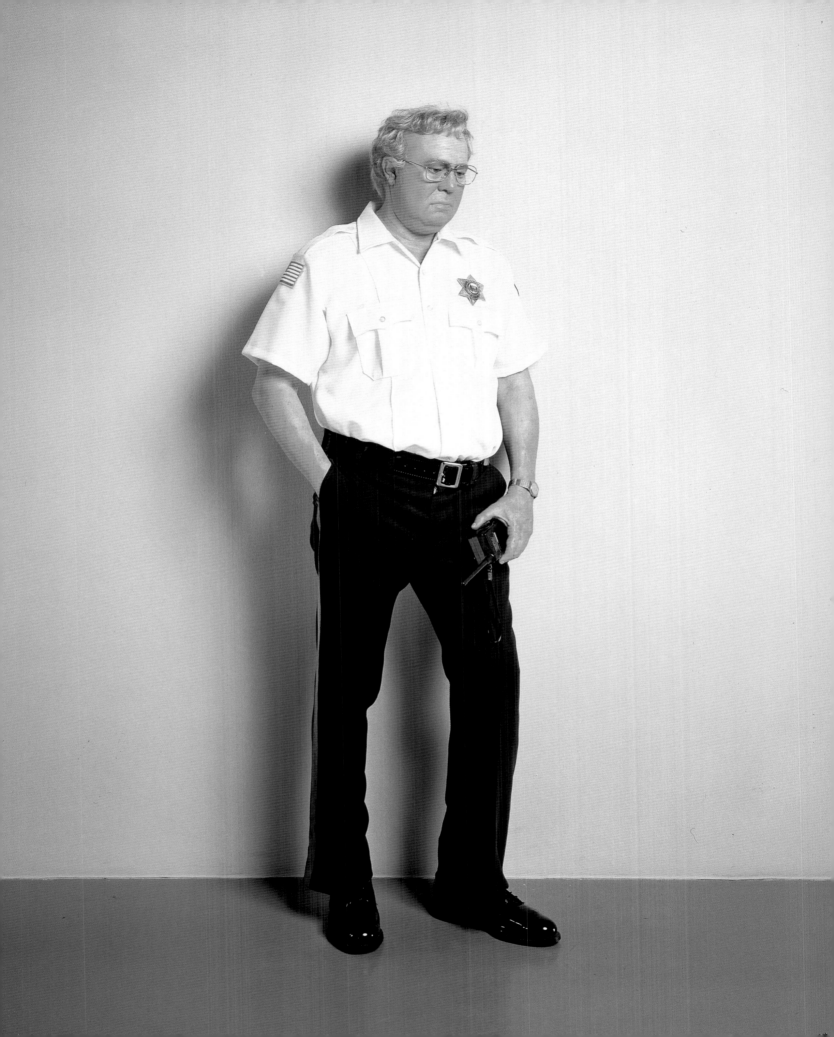

The Legacy of Duane Hanson in Contemporary Art

Elizabeth Hayt

During the 70s, when I was a teenager growing up on Long Island, my mother, an artist, would take me to Soho on Saturdays to go gallery hopping. A visit to O.K. Harris to see a Duane Hanson show was a thrill, especially compared to the linguistic brain-teasers and perplexing mounds of raw materials favored by the conceptual and process artists of the day. I remember marveling at the painstaking details of Hanson's forlorn figures, the blotchy complexion of the fat-faced woman in **Young Shopper** (1973), the wrinkled elbows of the retiree in **Man on a Bench** (1977–78). These sculptures, cast from life, produced in fiberglass and resin and dressed in contemporary clothes, looked so realistic, I expected them to take a breath and come to life, Pinocchio-style. Hanson, my Geppetto, displayed the kind of awe-inspiring craftsmanship that novice and pleasure seeking gallery goers could immediately appreciate.

But the sculptor's populist appeal and his pandering to bourgeois expectations of art were also a strike against him. During his career, which began in the late 60s, Hanson, who died in 1996, was disdained by art world elitists who perceived his work as the sculptural equivalent to less-than-serious Photo-Realism and nothing more than waxwork entertainment.

Recently, however, Hanson's sculpture has received new critical attention and significance, thanks to the current craze among contemporary artists for hyper-real figuration. In fact, it hardly seems coincidental that a series of retrospectives of Hanson's work has gained momentum throughout the 90s at the same time that mannequins have become the medium of choice for so many artists today. Since 1990, there have been no less than six surveys of his career. Hanson's sculptures—once hokey looking and contrived—now appear to be timely, as well as forerunners of much of the art of the last decade. Indeed, in Marco Livingstone's essay for the 1997 Hanson retrospective at the Saatchi Gallery in London, the author named many of today's American and British art stars, including Charles Ray, Robert Gober,

Security Guard 1990
auto-body filler, fiberglass and
mixed media, with accessories
Collection of Mrs. Duane Hanson

Jeff Koons, Jake and Dinos Chapman, Abigail Lane, and Gavin Turk, as heirs to the Hanson legacy.

"To me, Hanson looks like the Old Testament version of contemporary art," said Robert Rosenblum, professor of fine arts at New York University, who included the sculptor in his list of "the best of 1997" for *Artforum*. "I can't imagine writing the history of art without him being a father figure. His DNA has flowed into the 80s and 90s. He started that creepy closeness and distance between facsimiles of people and virtual reality. All of the current sci-fi versions look like later versions of that premise."

In an age of simulation, when computer technology and genetic engineering have destabilized our certainty about reality and originality, Hanson's corpus of human duplicates—so lifelike, his representations of museum guards have often been mistaken for the real thing—are a perfect expression of the artificiality of our times. Taking the idea of humanoids several steps further, contemporary artists like the British Chapman brothers, Jake and Dinos, have represented the freakier side of test-tube reproduction and human genome experiments. In **Six Feet Under**, a 1997 installation at the Gagosian Gallery in Soho, the artists created a mass grave filled with frolicking figures with multiple heads and limbs, as well as genitals sprouting from all the wrong places—an underworld populated by creatures created by replication gone awry.

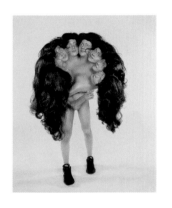

Dinos and Jake Chapman
British, Dinos born 1962,
Jake born 1966
Miss Many-Fanny (detail from Six Feet Under)
1997
fiberglass, resin, paint, wigs, shoes
53 x 27 x 27 inches
Courtesy of Gagosian Gallery, New York, New York

In 1993, artist Mike Kelley first identified a modern movement in art involving artificial human surrogates when he curated a show called "The Uncanny" at the Gemeentemuseum Arnhem in the Netherlands. Kelly included Hanson's **Riot** (1967) in the exhibition, along with an illustration of his **Janitor** (1973) in the catalogue. A range of other artists, including Hanson's contemporaries, like John de Andrea and Edward Kienholz, as well as a younger generation, such as John Miller, Tony Oursler, and Cindy Sherman, were featured in the show. Kelly sought to establish a trend among figural art based on Freud's definition of the uncanny: when something familiar appears strange, it can induce feelings of uncertainty and fear. In particular, waxwork figures, dolls, automatons, and the like, raising doubts about whether they are alive or dead, produce a sense of frisson. So do Hanson's sculptures.

Robert Storr, senior curator in the department of painting and sculpture at the Museum of Modern Art, elaborated on the uncanniness of Hanson's figures, linking them to contemporary sculpture. "The primary thing that stands out today with Hanson's figures is their unnaturalness because they have about them things that are real and already dated, like their clothes," Storr explained. "Their degree of

verisimilitude, and that they're totally dead, stands out much more prominently than it used to. Hanson is the precursor to Charles Ray and others who have played with facsimile bodies. Ray has made these figures to a standardized proportion. His whole idea is about the normative and the ideal. Hanson's whole idea is about the average American—how you are rather than how you should be."

Charles Ray's **Male Mannequin** (1990), one of his earliest examples of altering a catalogue-bought, Sears & Roebuck dummy to challenge the viewer's perception of an inanimate object and a living being, presents a nude male mannequin with realistic genitals cast from the artist's own body. The disjunction between the figure's Ken doll-like features and graphic genitalia, between the generic and the specific, the universal and the personal, not only causes a double take, it is unnerving.

Likewise, British artist Ron Mueck, a veteran of Jim Henson's Muppets workshop and stand-out of the 1997 *Sensation* show at the Royal Academy of Arts in London, relies on the psychologically acute and teasingly ambiguous to create eerie trompe l'oeil figures. By toying with scale, either increasing his figures to gigantic proportions or decreasing them to a diminutive size, as well as adding all-too-real touches like individual strands of hair, whiskers or goose flesh, Mueck invests his sculptures—first modeled in clay and then cast in silicone—with a sense of vulnerability. His **Dead Dad** (1996–97) is a three foot replication of his father's naked corpse, its small size being a pitiful reminder of the loss of dignity that comes with death. In contrast, Mueck's **Ghost** (1998), is a towering adolescent girl, measuring nearly six and a half feet tall. She leans against a wall, her face turned away from the viewer as if she is ashamed of her gangly figure, her knobby knees, dark hairy arms, big feet, stringy ponytail, and protruding upper lip. That the figure is larger than life only serves to make her discomfort and self-consciousness all the more palpable. She is almost too painful to look at.

Charles Ray
American, born 1953
Male Mannequin 1990
fiberglass and mixed media
73 1/2 x 28 x 20 inches
Courtesy of Gagosian Gallery,
New York, New York

Ron Mueck
American, born 1958
Dead Dad 1996–97
mixed media
7 7/8 x 40 1/8 x 15 inches
Courtesy of Anthony d'Offay
Gallery, London

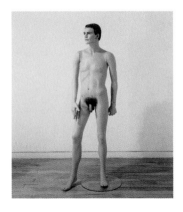

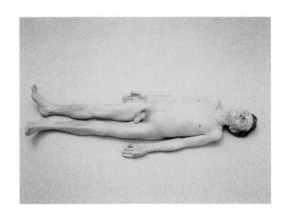

The psychological primacy of contemporary Mannequin Art is what distinguishes it from Hanson's, according to Paul Schimmel, chief curator of the Museum of Contemporary Art, Los Angeles. "When reality starts being manipulated and altered, re-presentation is more characteristic of the generation of the late 80s and 90s," he said. "There is a much stronger conceptual basis with stronger psychological content. Hanson dealt with politics outside himself whereas artists, like Ray and Gober, deal with the politics of themselves."

Supporting Schimmel's observation, artist Cindy Sherman explained why she began including prosthetic devices in her photographs in the late 80s and moved on to mannequins in the early 90s. "I work alone and sometimes I don't feel like being in the pictures," she said. "So I feel like working with a fill-in for myself. That can be creepy. That's what I like about mannequins."

Sherman's photographs, either depicting herself or mannequins as stand-ins, have long dealt with stereotypes of women as objects of desire, as well as their victimization. More recently, the Italian-born, New York-based artist Vanessa Beecroft has addressed cultural ideals of femininity but offers a post-feminist take on the idea of women as sexual subordinates. Rather than use mannequins as female surrogates, the artist inverts the relationship, presenting real women as lifeless bodies in performances in museum and gallery settings. In **Show** (1998) at the Guggenheim Museum in New York, she staged a live exhibition of 20 gorgeous models, five were nude and the rest were dressed in red rhinestone Gucci string bikinis, and stilettos, their already flawless figures enhanced with body make-up. For three hours, the women, who stood in a loose grid formation, did nothing more than pose, stretch, and occasionally sit on the floor to rest their sore feet, all the while ignoring the audience of 1500 viewers. The in-your-face beauty of the women, coupled with

Cindy Sherman
American, born 1954
Untitled 1992
color photograph, edition of 6
68 x 45 inches
Courtesy of the artist and
Metro Pictures, New York,
New York

Vanessa Beecroft
Italian, born 1969
Show April 23, 1998 at the
Solomon R. Guggenheim
Museum, New York, New York
performance
Courtesy of Deitch Projects,
New York, New York

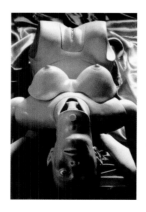
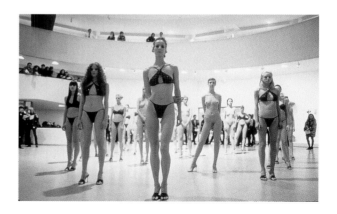

their aloofness, invested them with a passive aggressiveness that transformed the female model-cum-mannequin as an image of girl-power.

By looking at Hanson's figures through the lens of contemporary art, artist John Miller, who in the late 1980s began to use mannequins in his sculptural narratives, offers new interpretations of his predecessor's work. During Hanson's heyday in the 1970s, when he presented his figures in tacky, polyester clothes or uniforms, positioning them on lounge or folding chairs, and incorporating props, like soda cans and shopping bags, his art was dismissed as gimmicky. But, after two decades of post-modern art, with the reappraisal of pictorial narratives and allegories, Hanson's technique seems au courant. "Because they were super-realistic, people assumed Hanson's figures were naturalistic when, in fact, now they look allegorical," Miller observed. "I teach sculpture at Yale and last year, I was taking some slides out and it shocked me how timely Hanson's work looked."

In addition, Miller pointed out that Hanson's early works addressing the violence of American culture, like **Gangland Victim** (1967, p. 47) and **Motorcycle Accident** (1967), as well as his pathetic depiction of the downtrodden and disenfranchised, like blue collar workers and the elderly, could be redefined as abject art, one of the prevailing styles of the 90s. "After this wave of abject art, it makes it possible to see that there was a social mode of address in Hanson's work and it wasn't just Super-Realism," Miller said.

Since the early 90s, artist Paul McCarthy has used mechanized mannequins as his form of social commentary. Fabricating motorized dummies that are usually engaged in illicit sexual activities, McCarthy positions the figures in slipshod, theme park-like environments to depict a dark alternative to America's fun loving spirit. In **Yaa-Hoo**

John Miller
American, born 1954
Eat, Play, Divide 1993
mixed media
dimensions variable
Courtesy of the artist and Metro Pictures, New York, New York

Paul McCarthy
American, born 1945
The Bunkhouse (**detail from Yaa-Hoo Town**) 1995–96
mixed media installation
139 x 191 x 110 inches
Courtesy of the artist and Luhring Augustine, New York, New York
Photograph by Ron Amstutz

Town, his 1996 installation at Luhring Augustine Gallery in New York, McCarthy built an X-rated version of a Wild Wild West stage set complete with a saloon and bunkhouse where robotic, fiberglass, and resin cowboys and barmaids boozed it up, masturbated, and sodomized one another. This was no Hollywood or Disneyland rendition of Boomtown, USA but McCarthy's own nasty remake of how the West was really won.

While Hanson, marginalized by the art world during his lifetime, probably never expected to be elevated to the status of artistic forefather (and many would not grant him that title today), his ability to blur the distinction between reality and fiction makes him the antecedent to recent mannequin art. Not that contemporary artists are quick to point to him as influential. But, at a time when the artificial is on par with, if not indistinguishable from, the natural, when biology no longer equals destiny, when things are never what they seem, Hanson's sculptures no longer look anachronistic. More than twenty years after the fact, they could pass for the art of today. ∎

Medical Doctor 1994
polychromed bronze with
accessories
Private collection

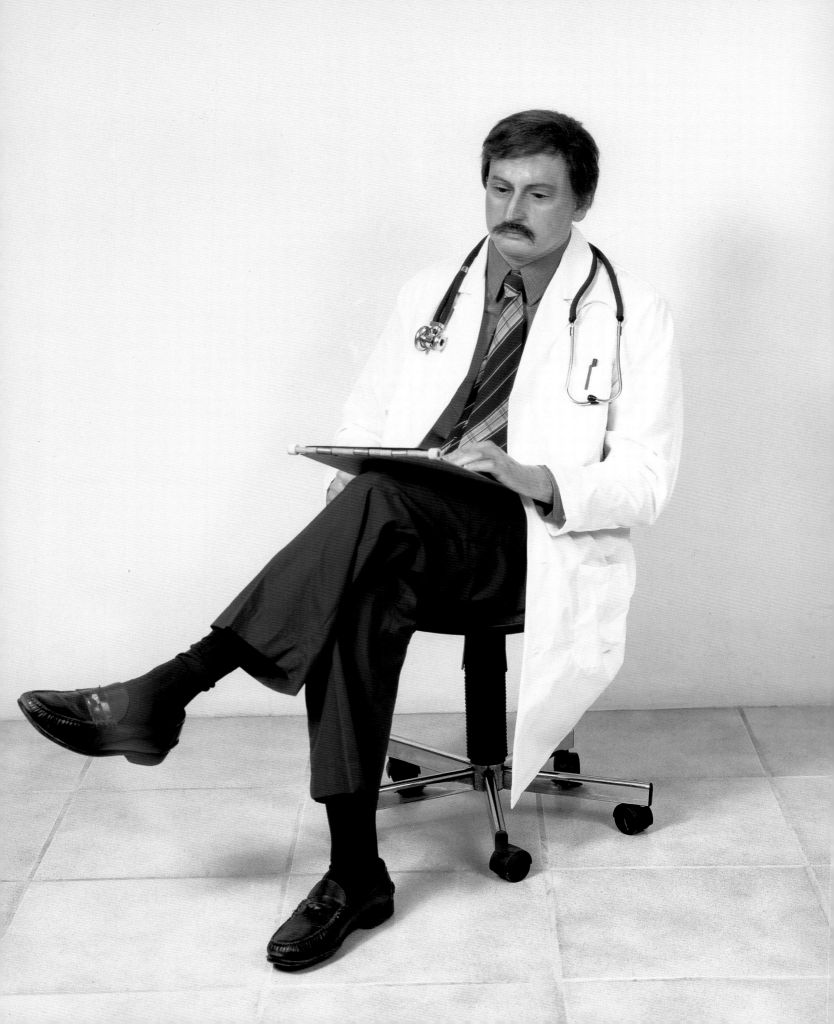

Catalog of the Exhibition

Old Woman in Folding Chair 1976
polyester resin and fiberglass;
polychromed in oil, with accessories
Collection of Mrs. Duane Hanson
Illus. p. 18

Child with Puzzle 1978
polyvinyl acetate and mixed media;
polychromed in oil, with accessories
Collection of Mrs. Duane Hanson
Illus. p. 24–25

Self-Portrait with Model 1979
polyvinyl acetate and mixed media;
polychromed in oil, with accessories
Collection of Mrs. Duane Hanson
Illus. p. 21

Children Playing Game 1979
polyvinyl acetate and mixed media;
polychromed in oil, with accessories
Collection of Mrs. Duane Hanson
Illus. p. 22

Fancy Dude Cowboy (Slim) 1986
polychromed bronze with accessories
Collection of the Skerik Family
Illus. p. 15

House Painter 1988
auto-body filler, fiberglass and mixed
media, with accessories
Private collection
Illus. p. 30

Queenie II 1988
auto-body filler, fiberglass and mixed
media, with accessories
Collection of the Artist's Estate
Illus. p. 28

Executive on Telephone 1988
polychromed bronze with accessories
Collection of Frederick Weisman
Entities, Los Angeles, California
Illus. p. 37

Beagle in Basket 1989
polychromed bronze and mixed
media, with accessories
Collection of Mrs. Duane Hanson
Illus. p. 16

**Lunch Break (Three Workers with
Scaffold)** 1989
auto-body filler, fiberglass and mixed
media, with accessories
Private collection
Illus. p. 78–79

All sculptures are life-size.

Man with Walkman 1989
auto-body filler, fiberglass and mixed
media, with accessories
Collection of the Artist's Estate
Illus. p. 12

Chinese Student 1989–90
auto-body filler, fiberglass and mixed
media, with accessories
Private collection
Illus. p. 40–41

High School Student 1990
polychromed bronze and mixed
media, with accessories
Collection of the Artist's Estate
Illus. p. 26

Flea Market Vendor 1990
auto-body filler, fiberglass and mixed
media, with accessories
Private collection
Illus. p. 8–9

Security Guard 1990
auto-body filler, fiberglass and mixed
media, with accessories
Collection of Mrs. Duane Hanson
Illus. p. 54

Man with Camera 1991
auto-body filler, fiberglass and mixed
media, with accessories
Collection of Mrs. Duane Hanson
Illus. p. 7

Car Dealer 1992–93
polychromed bronze and mixed
media, with accessories
Collection of the Artist's Estate
Illus. p. 6

Medical Doctor 1994
polychromed bronze with accessories
Private collection
Illus. p. 61

Policeman 1994
polychromed bronze and mixed
media, with accessories
Private collection
Illus. p. 34

**Mary Weisman (Mother of
Frederick R. Weisman)** 1994
polychromed bronze with accessories
Collection of Frederick Weisman
Entities, Los Angeles, California
Illus. p. 36

Body Builder 1995
auto-body filler, fiberglass and mixed
media, with accessories
Collection of Mrs. Duane Hanson
Illus. p. 31

Kid with a Baseball Bat 1995
auto-body filler, fiberglass and mixed
media, with accessories
Collection of the Artist's Estate
Illus. p. 42

Old Couple on a Bench 1995
polychromed bronze and mixed
media, with accessories
Collection of Palm Springs Desert
Museum: Purchase with funds
provided by Muriel and Bernard
Myerson
Illus. p. 10

Man on a Lawnmower 1995
polychromed bronze with Coke and
John Deere lawnmower
Collection of the Artist's Estate
Illus. p. 33

Selected Exhibitions and Collections

Selected Group Exhibitions

2000

Let's Entertain, Walker Art Center, Minneapolis, MN (scheduled to travel)

Cast of Characters: Figurative Sculpture, Albuquerque Museum, Albuquerque, NM

1999

Three Realist Sculptors, Nassau County Museum of Art, Roslyn Harbor, NY

The American Century: Art and Culture 1900–2000, Whitney Museum of American Art, New York, NY

Constructing Realities, Museum of Art at Brigham Young University, Provo, UT

1998

Selections from the Frederick R. Weisman Collection, Pepperdine University, Malibu, CA

1996

Homeland of the Imagination: The Southern Presence in 20th Century Art, NationsBank Plaza, Atlanta, GA

The Human Body in Contemporary American Sculpture, Gagosian Gallery, New York, NY

1994

Columbia Museum of Art, Columbia, SC

1992

In Search of Sunsets: The Persistence of Imagery in American Art, Tacoma Art Museum, Tacoma, WA

1991

La Sculpture contemporaine apres 1970, Fondation Daniel Templon, Fréjus, France

1989

Selected Works from the Frederick R. Weisman Foundation, Neuberger Museum, State University of New York, Purchase, NY

1988

Five Floridians, Helander Gallery, Palm Beach, FL

Trompe l'Oeil: The Magic of Deception, Muckenthaler Cultural Center, Fullerton, CA

Urban Figures, Whitney Museum of American Art at Philip Morris, New York, NY

Tortue is O.K., Tortue Gallery, Santa Monica, CA

1987

Florida Invitational, Part I, O.K. South, South Miami, FL

Independence Sites: Sculpture for Public Spaces, Independence Mall, Philadelphia, PA

Fifty-Fourth Annual Exhibition, Natural Sculpture Society, Port of History Museum at Penn's Landing, Philadelphia, PA

Pop Art America Europa dalla Collezione Ludwig, Forte di Belvedere, Florence, Italy

1986

Figure as Subject: The Last Decade, The Whitney Museum of American Art at the Equitable Center, New York, NY

Boston Collects: Contemporary Painting and Sculpture, Museum of Fine Arts, Boston, MS

New Work—New York, Helander Gallery, Palm Beach, FL

Michigan People: Photographs from People Magazine, Detroit Institute of Arts, Detroit, MI and Millesgarden, Lidingo, Sweden

Art in the Environment, Boca Raton Museum of Art, Boca Raton, FL

Contemporary Sculpture from the Martin Z. Margulies Collection, Grove Isle, Coconut Grove, FL

1985

Artists of O.K. Harris, Helander/Rubenstein Gallery, Palm Beach, FL

Fortissimo! Thirty Years of the Richard Brown Baker Collection of Contemporary Art, Museum of Art, Rhode Island School of Design, Providence, RI (traveling exhibition)

Selected Works: The Frederick R. Weisman Foundation of Art, Art Center College of Design, Pasadena, CA

The Real Thing, North Miami Museum and Art Center, North Miami, FL

Figure It Out: Exploring the Figure in Contemporary Art, Laguna Gloria Art Museum, Austin, TX

Pop Art: 1955–1970, International Council of the Museum of Modern Art, New York, N.Y., and Art Gallery of New South Wales, Sydney, Australia, (traveling exhibition)

1984

Contemporary Trompe l'Oeil Painting and Sculpture, Bellevue Art Museum, Bellevue, WA.

In Quest of Excellence, Center for the Fine Arts, Miami, FL

O.K. Harris Artists, Royal Palm Gallery, Palm Beach, FL

Image, Effigy, Form: Figurative Sculpture, University Art Museum, California State University, Long Beach, CA

The Lewis and Clark Collection, Portland Center for the Visual Arts, Portland, OR

Return of the Narrative, Palm Springs Desert Museum, Palm Springs, CA

Citywide Contemporary Sculpture Exhibition, Toledo Museum of Art, Toledo, OH

Figurative Sculpture: Ten Artists/Two Decades, University Art Museum, California State University, Long Beach, CA

American Art from the Frederick R. Weisman Foundation Collection, San Francisco Art Institute, San Francisco, CA

Games of Deception: When Nothing Is As It Appears, Artisan Space, Fashion Institute of Technology, New York, NY

1983

Contemporary Trompe l'Oeil Painting and Sculpture, Boise Gallery of Art, Boise, ID, (traveling exhibition)

Duane Hanson and His Works, West Palm Beach Library, West Palm Beach, FL

Icons of Contemporary Art, Foster Goldstrom, Dallas, TX

American Super Realism from the Morton G. Neumann Family Collection, Terra Museum of American Art, Evanston, IL

Time Out: Sport and Leisure in America Today, Tampa Museum, Tampa, FL

Realism Now, Museum of Modern Art, Saitama, Japan

1982

Five in Florida, North Miami Museum and Art Center, Miami, FL

Realist Exhibition, Philadelphia Academy of Art, Philadelphia, PA

Artists Speak for Peace, Trinity Cathedral Hall, Miami, FL

Five Artists and the Figure, Whitney Museum of American Art, New York, NY, (traveling exhibition)

Cranbrook U.S.A., Cranbrook Academy of Art/Museum, Bloomfield Hills, MI

1981

Real, Really Real, Super Real, San Antonio Museum of Art, San Antonio, TX, (traveling exhibition)

Whitney Biennial Exhibition, Whitney Museum of American Art, New York, NY

Contemporary American Realism Since 1960, Pennsylvania Academy of Fine Arts, Philadelphia, PA

International Florida Artists, John and Mable Ringling Museum of Art, Sarasota, FL

Southern Monumental: An Invitational Exhibition of Monumental Art by Southern Artists, University Gallery, Memphis State University, Memphis, TN

1980

Mysterious and Magical Realism, Aldrich Museum of Contemporary Art, Ridgefield, CT

The Morton G. Neumann Collection, National Gallery of Art, Washington, D.C.

The Figurative Tradition and the Whitney Museim of American Art: Painting and Sculpture from the Permanent Collection, Whitney Museum of American Art, New York, NY

International Florida Artists, John and Mable Ringling Museum of Art, Sarasota, FL

Form and Figure, Boise Art Museum, Boise, Idaho, (traveling exhibition)

Eleventh International Sculpture Conference, Washington, D.C.

Sculpture, Medici-Berenson Gallery, Bay Harbor Island, FL

Aspects of the 70s—Directions in Realism, Danforth Museum, Framingham, MA

The Lewis Contemporary Art Fund Collection, Virginia Museum of Fine Arts, Richmond, VA

Rosc 80, National Gallery of Ireland and University College, Dublin Arts and Crafts Center, Pittsburgh, PA

The 10th Dade County Art Education Association Exhibition, Visual Arts Gallery, Florida, International University, Miami, FL

1979

Figure of Five, Gallery of North Campus, Miami-Dade Community College, Miami, FL

Reality of Illusion, Denver Art Museum, Denver, CO (traveling exhibition)

1978

Matrix 40, Wadsworth Atheneum, Hartford, CT

Aspekte der 6oer Jahre: Aus der Sammlung Reinhard Onnasch, Nationalgalerie, Berlin, Germany

1977

Eight Contemporary American Realists, Pennsylvania Academy of the Fine Arts, Philadelphia, PA (traveling exhibition)

Centre National d'Art et de Culture George Pompidou, Paris, France

Whitney Biennial, Whitney Museum of American Art, New York, NY

Aachen Ludwig Collection 1977: The Artist Exhibited, Neue Galerie, Aachen, Germany

Art Around 1970, Sammlung Ludwig, Aachen, Germany

1976

Aspects of Realism, Gallery/Stratford & Rothmans of Pall Mall, Ltd., Stratford, Ontario, Canada, (traveling exhibition)

Fine Arts Festival, Kent State University, Kent, OH

Group Show, O.K. Harris Gallery, New York, NY

Photo Realism: U.S.A., Edwin A. Ulrich Museum of Art, Wichita State University, Wichita, KS

Selected Solo Exhibitions

2000

Duane Hanson: Virtual Reality, Palm Springs Desert Museum, Palm Springs, CA (traveling exhibition)

1999

Duane Hanson, Ballroom, Royal Festival Hall, London, England

1998

Duane Hanson, A Survey of his Work from the 30's to the 90's, Museum of Art, Fort Lauderdale, FL, (traveling exhibition)

Duane Hanson, A Master Returns, Oglethorpe University Museum, Atlanta, GA

1997

Duane Hanson: The Saatchi Gallery, The Saatchi Gallery, London, England

1995

Marisa Del Re O'Hara Gallery, New York, NY and Palm Beach, FL

Duane Hanson, Daimaru Museum, Tokyo, Japan (traveling exhibition)

1994

Duane Hanson, The Montreal Museum of Fine Arts, Canada, (traveling exhibition)

1993

Eve Mannes Gallery, Atlanta, GA

1992

Helander Gallery, New York, NY

Duane Hanson: Sculpture/Skulpturen, Galerie Neuendorf, Frankfurt, Germany

1991

Gallery of Art, Jackson County Community College, Overland Park, KS

Duane Hanson: The New Objectivity, Florida State University Gallery and Museum, Tallahassee, FL

1990

Brown University Art Museum, Providence, RI

Kunsthalle Tubingen, Tubingen, Germany, (traveling exhibition)

1989

World Design Exposition 89, Nagoya, Japan

The Contemporary Museum, Honolulu, HI, (traveling exhibition)

1988

Auckland City Art Gallery, New Zealand, (traveling exhibition)

Real People: Sculpture by Duane Hanson, Museum of Art, Ft. Lauderdale, FL

1987

Ruin Stone Museum, Alexandria, MN

Swedish American Institute, Minneapolis, MN

1986

Carl Milles Garden, Lidingo, Sweden

1985

Cranbrook Academy of Art Museum, Bloomfield Hills, MI

Sculptures by Duane Hanson, Edwin A. Ulrich Museum of Art, Wichita State University, Wichita, KS, (traveling exhibition)

1984

O.K. Harris Works of Art, New York, NY

Hyper-Realist Sculpture of Duane Hanson, Isetan Museum of Art, Tokyo, Japan

1981

Duane Hanson, Jacksonville Art Museum, Jacksonville, FL, (traveling exhibition)

1980

O.K. Harris Works of Art, New York, NY

1979

Whitney Museum of American Art, New York, NY

1978

Corcoran Gallery of Art, Washington, D.C.

1977

Des Moines Art Center, Des Moines, IW

University Art Museum, Berkeley, CA

Portland Art Museum, Portland, OR

William Rockhill Nelson Gallery and Atkins Museum of Fine Art, Kansas City, MO

Colorado Springs Fine Arts Center, Colorado Springs, CO

Virginia Museum of Fine Arts, Richmond, VA

1976

University of Nebraska Art Galleries, University of Nebraska at Lincoln

Duane Hanson, O.K. Harris Works of Art, New York, NY

Duane Hanson, Edwin A. Ulrich Museum of Art, Wichita State University, Wichita, KS (traveling exhibition)

Upcoming Solo Exhibitions

2003

Ludwig Gallery, Schloss Oberhausen, Germany

UNESCO World Cultural Heritage, European Centre for the Arts and Culture, Volkingen, Germany

2002

Galerie der Stadt, Stuttgart, Germany

Padiglione d'Arte Contemporanea, Milano, Italy

Kunsthal Rotterdam, The Netherlands

2001

Schirn Kunsthalle, Frankfurt, Germany

Public Collections

Australia

The Art Gallery of South Australia, Adelaide

Austria

Museum des 20, Jahrhunderts, Vienna

Denmark

Louisiana Museum of Modern Art, Humleboek

Germany

Ludwig Forum, Aachen

Museum Ludwig, Cologne

Museum Weserburg, Bremen

Neue Galerie, Aachen

Sprengel Museum, Hanover

Staatsgalerie, Stuttgart

Stiftung Haus der Geschichte der Bundesrepublik Deutschland, Bonn

Wilhelm Lehmbruck Museum, Duisburg

The Netherlands

Museum Boymans-van Beuningen, Rotterdam

Museum of Contemporary Art, Utrecht

Scotland

Scottish National Gallery of Modern Art, Edinburgh

USA

The Art Museum, Florida International University, Miami, Florida

Cranbrook Academy of Art Museum, Bloomfield Hills, Michigan

Flint Institute of Arts, Flint, Michigan

Frederick R. Weisman Art Museum, Minneapolis, Minnesota

Gallery of Contemporary Art, Lewis and Clark College, Portland, Oregon

Hunter Museum of American Art, Chattanooga, Tennessee

Kemper Museum of Contemporary Art, Kansas City, Missouri

Kresge Art Museum, Michigan State University, East Lansing, Michigan

Lowe Art Museum, University of Miami, Coral Gables, Florida

Milwaukee Art Museum, Milwaukee, Wisconsin

The Nelson-Atkins Museum of Art, Kansas City, Missouri

Norton Museum of Art, West Palm Beach, Florida

Palm Springs Desert Museum, Palm Springs, California

Virginia Museum of Fine Arts, Richmond, Virginia

Wadsworth Atheneum, Hartford, Connecticut

Whitney Museum of American Art, New York

Yale University Art Gallery, New Haven, Connecticut

Selected Bibliography

Albright, Thomas. *Art in the San Francisco Bay Area: 1945–1980*. Berkeley: University of California Press, 1985.

Armuts Zeugnisse. Fritz-Huser-Institut/Museum am Ostwall, Elefanten Press, Berlin, Germany, 1995.

Ashton, Dore. *American Art Since 1945*. New York: Oxford University Press, 1982.

Barnett, Catherine. "Wise Men Fish Here: Seven Contemporary Artists Talk about Why They Went and What They Found in Florida." *Art & Antiques*, February 1988.

Bass, Ruth. "Duane Hanson." *ARTnews*, Vol. 94, Issue 9, November 1995.

Battcock, Gregory, ed. *Super Realism*. New York: E.P. Dutton & Co., Inc., 1975.

Broward County 1983 Cultural Directory. Fort Lauderdale: Broward Arts Council, 1983.

Brown, Milton W., et al. *American Art*. New York: Harry N. Abrams, Inc., 1979.

Bush, Martin H. *Duane Hanson*. Wichita: Edwin A. Ulrich Museum of Art, Wichita State University, 1976.

_____. "Martin Bush Interviews Duane Hanson." *Art International*, September 1977.

_____ and Thomas Buchsteiner. *Duane Hanson, Skulpturen*. Stuttgart: Edition Cantz, 1990.

_____ and Sumio Kuwabara. *Hyper-Realist Sculptures of Duane Hanson*. Tokyo: Isetan Museum of Art, 1984.

_____. *Sculptures by Duane Hanson*. Wichita: Edwin A. Ulrich Museum of Art, Wichita State University, 1985.

Chase, Linda. *American Super Realism from the Morton G. Neumann Family Collection*. Evanston: Terra Museum of American Art, 1983.

_____. *Hyperrealism*. New York: Rizzoli, 1975.

_____ and Ted McBurnett. ''The Verist Sculptors: 2 Interviews.'' *Art in America*, November/December l972.

Cosford, Bill. "Arts Were Seen But Not Heard." *The Miami Herald*, April 28, 1983

Diehl, Carol. "Reviews." *ARTnews*, Vol. 92 Issue 1, January 1993.

Documenta Archiv. Kassel: Documenta Archiv, Germany, 1996.

Documenta 5: Befragnung der Realitat. Beldwelten heute. Kassel: Verlag Documenta GmbH, 1972.

"Duane Hanson." *USA Today Magazine*, Vol. 127 Issue 2648, May 1999.

Edward, Ellen. "Duane Hanson's Blue Collar Society.'' *ARTnews*, April 1978.

Fleming, William. *Arts and Ideas*. New York: Holt, Rinehart, and Winston, 1980.

The Frederick R. Weisman Foundation. *Selected Works of the Frederick R. Weisman Foundation*, Los Angeles: The Frederick R. Weisman Foundation, 1989.

Gardner, James. "Still Lives." *National Review*, Vol. 51 Issue 2, February 8, 1999.

Goodyear, Frank H., Jr. *Contemporary American Realism Since 1960*. New York: Graphic Society Books, Little Brown and Company, Publishers, 1981.

Grande, John K. "Duane Hanson: The Other Side of the American Dream/L'-Envers du reve americain." *Espace*, Summer 1994.

Greenwood, Michael. "Current Representational Art, Five Other Visions: Duane Hanson and Joseph Raffael." *ArtsCanada*, December-January 1977

Grover, J.Z. "Show in Hansonville." *Twin Cities Reader*, Vol. 21 Issue 35, September 6, 1995.

Hanson, Duane. "Presenting Duane Hanson.'' *Art in America*, September 1970.

_____. *Duane Hanson: erste Retrospektive des amerikanischen Bildhauers*. Stuttgart: urttembergischer Knustverein, Germany, 1974.

Hayt, Elizabeth. "In an Era of Humanoid Art, A Forerunner Finds a Place." *New York Times*, Vol. 148 Issue 51370, December 13, 1998.

Heidelberg, Paul. "I Was a Duane Hanson Model: A Sculptor's Muse Faces Some Thoroughly Modern Indignities." *Art & Antiques*, January 1993.

Helander, Bruce. *Real People: Sculpture by Duane Hanson*. Ft. Lauderdale: Museum of Art, 1988.

Hills, Patricia and Roberta K. Tarbell. *The Figurative Tradition and The Whitney Museum of American Art*. Newark: University of Delaware Press; London and Toronto: Associated University Presses, 1980.

Hobbs, Robert Carleton. *Duane Hanson: The New Objectivity*. Tallahassee: Florida State University Gallery and Museum, 1991.

Houle, Alain. "Duane Hanson ou la recontre du troisieme type." *Lectures*, April 1994.

Hughes, Robert. "The Realist as Corn God." *Time*, January 31, 1972.

_____."Making the Blue-Collar Waxworks." *Time*, February 20, 1978.

Hunter, Sam and John M. Jacobus. *American Art of the 20th Century: Painting, Sculpture, Architecture*. Englewood Cliffs: Prentice-Hall, 1973.

Johnson, Ellen H., ed. *American Artists On Art*. New York: Harry N. Abrams, Inc., 1976.

_____. *American Artists on Art from 1940 to 1980*. New York: Harper & Row, 1982.

Kimmelman, Michael. "Duane Hanson, 70, sculptor of super-realistic figures, dies." *New York Times*, Vol. 145 Issue 50302, January 10, 1996.

Kinnemann, Emily. "Duane Hanson's Sunbather Study I, 1990." *Kresge Art Museum Bulletin*. Lansing: Michigan State University, 1999.

Kirwin, Liza. "Notice of oral interview." *Archives of American Art Journal*, March 1989.

Kuspit, Donald B. "Duane Hanson's American Inferno." *Art in America*, November/December 1976.

_____. *Homeland of the Imagination: The Southern Presence in Twentieth Century Art*, Georgia: NationsBank Plaza, 1996.

Levin, Gail. *Edward Hopper: The Art and the Artist*. New York: W.W. Norton & Co., 1980.

Lindey, Christine. *Superrealist Painting and Sculpture*. New York: William Morrow and Company, Inc., 1980.

Livingstone, Marco. *Duane Hanson*. Montreal: The Montreal Museum of Fine Arts, 1994.

_____. "Duane Hanson (1925–1996): Confrontations with Our Selves." *Contemporary Art*, Late Spring 1996.

_____. *Duane Hanson: The Saatchi Gallery*. London: The Saatchi Gallery, 1997.

_____. *Duane Hanson*. Tokyo: Daimaru Museum, Art Life Ltd., Tokyo, 1995.

_____. *Pop Art: A Continuing History*. London: Thames and Hudson; New York: Harry N. Abrams, Inc., 1990.

_____ and Laurence Pamer. *Duane Hanson: A Survey of His Work from the '30s to the '90s*. Fort Lauderdale: Museum of Art, 1998.

Louisiana Museum of Modern Art. *Duane Hanson*. Humleboek: Louisiana Museum of Modern Art, Denmark, 1975.

Lucie-Smith, Edward. *Art In The Seventies*. Ithaca: Cornell University Press, 1980.

_____. *American Realism*. London: Thames and Hudson, 1994.

_____. *Super Realisim*. Oxford: Phaidon, 1979.

_____. *Art Now*. New York: William Morrow and Company, Inc., 1981.

_____. *Late Modern: The Visual Arts Since 1945*. New York: Praeger Publishers, 1976.

Masheck, Joseph. "Verist Sculpture: Hanson and DeAndrea." *Art in America*, November/December 1972.

Mathews, Margaret. ''Duane Hanson: Super Realism.'' *American Artist*, September l981.

Mathzy, Francois. *American Realism*. New York: Rizzoli International Publications, Inc., 1978.

May, Stephen. "Reviews." *ARTnews*, Vol. 98 Issue 2, February 1999.

Morgan, Robert C. "Duane Hanson's Documentary Sculpture." *USA Today, (Journal of the Society for the Advancement of Education)* March 1982.

Musee des beaux-arts de Montreal. *She'll never change. She's one of Duane Hanson's Sculptures*. Montreal: Musee des beaux-arts, 1994.

Museum of Contemporary Art. *The Real and Ideal in Figurative Sculpture*. Chicago: The Museum of Contemporary Art, 1974.

Newhall, Edith. "Dead Wrong." *ARTnews*, Vol. 94 Issue 6, Summer 1995.

Reno, Doris. "Taste Marks Sculptors of Florida Annual." *The Miami Herald*, October 30, 1966.

Richard, Paul. "Mind Meets Spirit: Psychiatrists Ponder." *The Miami Herald*, June 29, 1971.

Roukes, Nicholas. *Sculpture In Plastics*. New York: Watson-Guptill Publications, 1978.

Rugoff, Ralph and Anthony Vidler and Peter Wollen. *Scene of the Crime*. Los Angeles: Armand Hammer Museum of Art and Cultural Center, University of California Los Angeles, 1997.

Ruhrberg, Karl and Eckart Britsch. *Duane Hanson: Sculptures/Skuplturen*. Frankfurt: Galerie Neuendorf AG, 1992.

Saltz, Jerry. "Duane Hanson at Helander." *Art in America*, Vol. 81 Issue 1, January 1993.

Sandler, Irving. *American Art of the 1960s*. New York: Harper & Row, 1988.

Savage, Jim. "Sculpture 'Too Grisly', Banned from Exhibit." *The Miami Herald*. June 18, 1968.

Schjeldahl, Peter. "Stilled Lives." *New Yorker*, Vol. 74 Issue 41, January 11, 1999.

Schudel, Matt. "Mr. Hanson's Neighborhood.'' *Sun-Sentinel, Sunshine Magazine*, December 18, 1988.

Smith, Griffin. "Don't Eat Before You Visit Lowe." *The Miami Herald*, February 16, 1969.

Smith, Roberta. "Tenderly Replicating the Banal." *New York Times*, Vol. 148 Issue 51375, December 18, 1998.

Snider, Fran. "Lively Arts World Invades Hollywood." *The Miami Herald*, February 4, 1968.

Stevens, Mark. "Prussian Blues." *New York*, Vol. 31 Issue 50, January 4, 1999.

Tacoma Art Museum. *In Search of Sunsets: Images of the American West 1850 to Present*. Tacoma: Tacoma Art Museum, 1992.

Taylor, Joshua C. *America As Art*. Washington: Smithsonian Institution Press, 1976.

_____. *The Fine Arts in America*. Chicago: The University of Chicago Press, 1979.

Varnedoe, Kirk. "Duane Hanson: Retrospective and Recent Work." *Arts Magazine*, January 5, 1975.

_____. *Duane Hanson*. Jacksonville: Jacksonville Art Museum, 1981.

_____. *Duane Hanson*. New York: Harry N. Abrams, Inc., 1985.

Whitney Museum of American Art. *Five artists and the figure: Duane Hanson*. Stanford: Whitney Museum of American Art, Fairfield County, 1982.

Willis, Will. "Corpse Livens Art Festival." *The Miami Herald*, April 10, 1967.

Wilmerding, John. *American Art*. New York: Penguin Books, 1976.

Wohlfert, Lee. ''At Duane Hanson's Strange New Show, Only the Artist is Lying Down on the Job.'' *People*, March 6, 1978.

Overleaf:
Lunch Break (Three Workers with Scaffold)
1989
auto-body filler, fiberglass and mixed media, with accessories
Private collection
Photograph by R. H. Hensleigh

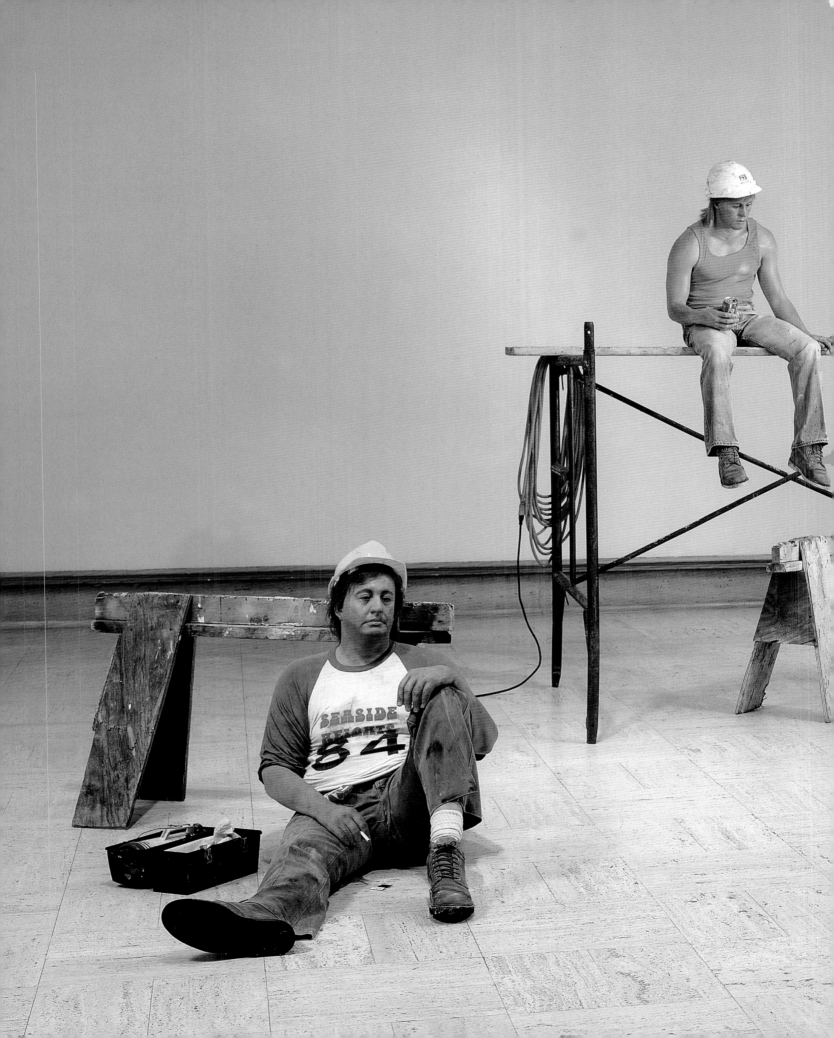

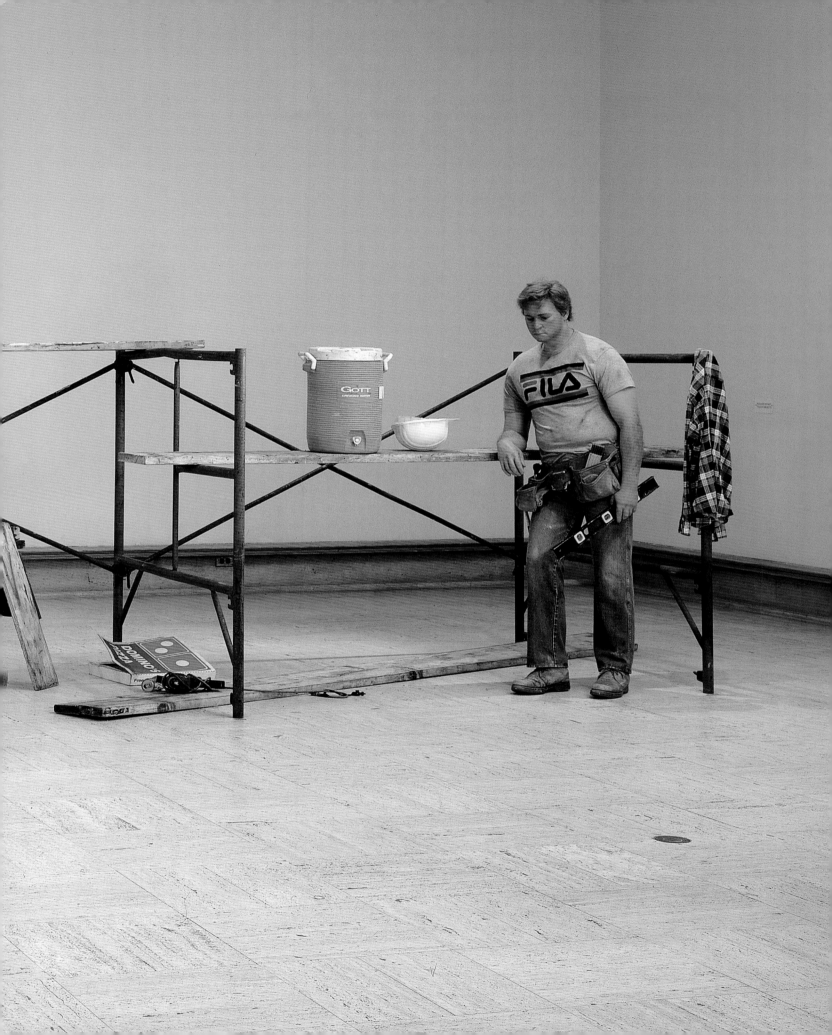

Palm Springs Desert Museum

Board of Trustees 2000–2001

Robert E. Armstrong, *President*
Ms. Lee Appel, *Vice-president*
John E. FitzGerald III, *Vice-president*
Robert L. Dickey, *Vice-president*
Robert J. Fraiman, *Vice-president*
Mrs. Edward Redstone, *Vice-president*
Stephen G. Hoffman, *Treasurer*
Martin Martinez, *Assistant Treasurer*
Mrs. Patricia Murphy Newman, *Secretary*
Mark Manocchio, *Assistant Secretary*
Mrs. Barbara Pitts, *Past President*

Mrs. Richard Bloch
Mrs. David Browne
Mrs. Georgia Fogelson
Henry L. Freund
Mrs. Jerome Goldstein
Mrs. Josef Gorelik
James R. Greenbaum
Ms. Jean Ann Hirschi
Mrs. Jackie Lee Houston
Mrs. Maury Page Kemp
Mrs. Theodore Lerner
Juan M. Lujan
David Lurie
Mrs. Cargill MacMillan Jr.
Mrs. Harold Matzner
Mrs. JoAnn McGrath
Mrs. John Moore
Mrs. Mervin G. Morris
Mrs. Bernard Myerson
Mrs. George E. Nadler

Mrs. Carl D. Pearl
Albert A. Robin
Sam Rubinstein
Henry Sanchez
Neal Schenet
Gilbert Schnitzer
Mrs. Howard Schor
Richard Shalhoub
Mrs. Hortense Singer
Michael V. Smith
Mrs. Marion Stone
Charles Tatum
Bruce Throckmorton
Ms. Judy Vossler
Mrs. Marybeth Waterman
Stewart Woodard
Ms. Gwen Weiner
Mrs. Alexander Wernicke
Mrs. Robert Zimmer

Honorary Board of Trustees

Mrs. Gerald R. Ford, *Honorary Chairman*
Mrs. Marvin Davis
Barry Manilow
Mrs. Luella Maslon
Sidney Sheldon
Mrs. Alexandra Sheldon
Mrs. Frank Sinatra

Past Presidents

Edward F. Anixter
Mrs. Walter H. Annenberg
Marshall M. Gelfand
Mrs. John Hardy

Trustees Emeritus

Mrs. Morris Bergreen
Harold C. Broderick
Mrs. Kirk Douglas
Dr. Alan Leslie
Mrs. Tony Rose
Stanley Rosin
Harold E. Stack